IMAGES
of America

CHOCTAW NATION
OF OKLAHOMA

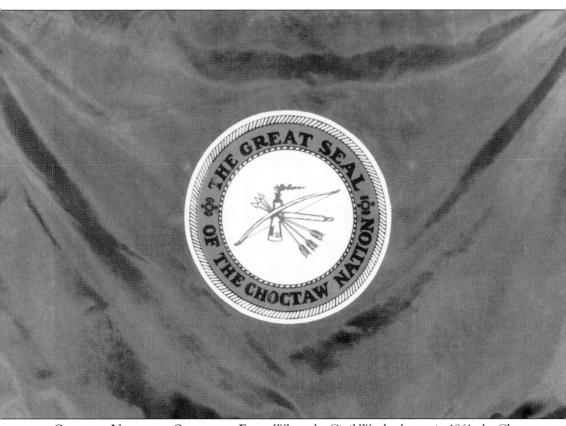

CHOCTAW NATION OF OKLAHOMA FLAG. When the Civil War broke out in 1861, the Choctaws sided with the Confederacy and during this alliance became the first American Indian tribe to develop a tribal flag. The current flag has evolved from various colors, but the present flag is purple with the Choctaw seal in the center. The inner circle has a sacred pipe and a bow with three arrows on a yellow background. Rising from the pipe bowl is black smoke. The blue ring is edged on each side with a green cord design. "The Great Seal of the Choctaw Nation" is in black lettering in the blue ring area. The pipe represents their history and deliberation around council fires. The three arrows symbolize three great Choctaw chiefs—Apuckshunnubbee, Pushmataha, and Mosholatubbee—who signed the Treaty of Doaks Stand (1820), by which the United States assigned the tribe land in Indian Territory (present southern Oklahoma) in exchange for Choctaw land in Mississippi. The new land in the west was divided into three districts, each named for one of the three chiefs. The Choctaw were peace-loving but would string their bows to defend themselves if necessary. Pushmataha embodied the nature of the tribe and was the tribal hero and statesman who became the tribal leader in war. Provision was made for this seal at the Choctaw convention at Doaksville, Indian Territory, in 1890. The Choctaw Nation of Oklahoma flag was presented to Donovin Sprague by Choctaw tribal member Carl Davis. (Courtesy of Donovin Sprague.)

On the cover: Please see page 95. (Photograph by Andrew T. Kelley; courtesy of Jones Academy Museum.)

IMAGES
of America

CHOCTAW NATION
OF OKLAHOMA

Donovin Arleigh Sprague

ARCADIA
PUBLISHING

Published by Arcadia Publishing
Charleston SC, Chicago IL, Portsmouth NH, San Francisco CA

Printed in the United States of America

Library of Congress Catalog Card Number: 2006937457

For all general information contact Arcadia Publishing at:
Telephone 843-853-2070
Fax 843-853-0044
E-mail sales@arcadiapublishing.com
For customer service and orders:
Toll-Free 1-888-313-2665

Visit us on the Internet at www.arcadiapublishing.com

*Dedicated with love to Darrel and Velda Sprague,
and Bob Pearson and Nell (White) Pearson*

CONTENTS

Acknowledgments 6

Introduction 7

1. Chahta Tikbanli Isht Anumpa
 (Early Choctaw History) 9

2. Chahta Okla Hattak Vpi Humma I Yakni
 (Choctaw Nation Indians Their Land) 17

3. Oklahoma Chahta Okla
 (Choctaw Nation of Oklahoma) 23

4. Chahta Nan Ikhvna Holisso Apisa
 (Choctaw Education and Schools) 71

5. Chahta Hihla Micha Kaniohmi Hosh Asha
 (Choctaw Dance and Culture) 91

6. Chahta Tvska Lumvt Anumpuli
 (Choctaw Warriors Code Talkers) 99

7. Himak Nittak Chahta Okla
 (Today's Choctaw Nation) 105

Resources 124

Index 125

ACKNOWLEDGMENTS

My thanks and appreciation to the following friends, past and present, who provided photographs, interviews, generosity, and friendship: Judy Allen; Paula Anderson family; Atoka County Library, Atoka, Oklahoma; Hoyt Axton; Mike Bailey; Marcia Ball; Lou Ann Barton; *Bishinik* newspaper; George and Jane Bishop; Doyle Bramhall; Doyle Bramhall II; Eddie Brigati; Clarence "Gatemouth" Brown; Bryan County Historical Society; Bonnie Chaffin; Choctaw Codetalkers; Choctaw Nation of Oklahoma; Jay Citron; Eddy Clearwater; Confederate Memorial Museum, Atoka, Oklahoma; Crazy Horse Tiwahe; Carolyn Cross; Charlie Daniels; Dorrie Denny; Dina Deupree; Ephriam Dickson; Chris Duarte; Tinsley Ellis; Juanita Estes; Fabulous Thunderbirds; Fort Washita-Marie Brearley; Denny Freeman; Clyde and Elsie Frost; Lane Frost; Todd Gabry; Chief Clark David Gardner; Billy Gibbons; Ferman and Trudy Gill; Bill and Pat Gilmore; Margaret Gipson; Randie Ary Graves; Renee Greenman; Jerri Hadley; Merle Haggard; Rob Handago; Berl and V. Jones Harrell; Ted Harvey; Mel Hayes; Mike He Crow; Tuff Hedeman; Stephanie Hill; Margaret Hogan family; LeAnne Howe; Hump Tiwahe; Indian Territory Museum, Caddo, Oklahoma; Waylon Jennings and Jessi; E. J. Johnson; Jones Academy; Jones Academy Museum and Library; Toby Keith; Clara Sue Kidwell; Albert King; B. B. King; Freddie King; Cody Lambert; Bess LeFlore; Raymond Lewis; Sis Lewis; David and Joanie Lindley; Barbara Logan; Tommy Lytle family; Reba McEntire; Elizabeth Tonihka McKinney; Billie Southard Merit; Jo Dee Messina; Berneita Miller; Mississippi Band of Choctaw Indians; Michael Martin Murphey; Kenny Neal; Beverly Nelson; Bobbie Nelson; Willie Nelson; Monte Olsen; Melvin Panter; Euell and Linda Perry; Judith Perry; Arthur Pittman; Pooley family; Marcie Pudwill family; Dylan Pudwill; Chief Greg Pyle; George Rains; David Ray family; Thomas "Tinker" and Elma Lou Ray; Lisa Reed; Lillie Roberts; Jimmy Rogers; Tracy Russell; Morris Sam; Brenda Samuels; Patti Scott; Lila Serfling; Tommy Shannon; Mark Shillingstad; Nancy Sinatra; Joe Sirmans; Inez Sitter; Johnny Smith; Robert Smith; Southeastern Oklahoma State University; Deb Sprague; Brandon and Nancy Sprague; Rylan Sprague and Rosie; Linda Stampoulos; Gene Taylor; Koko Taylor; Hank Thompson; Ben Trent; Clint Trent family; Mike Trent family; Russell Transue; Tanya Tucker; Twin Cities Heritage Museum-Hartshorne, Oklahoma; University of Oklahoma; Vance family; Jimmie Vaughan; Stevie Ray Vaughan; Wakan Tanka; Gwen Walker; Cindy Wallis; White family; Rex White; Tommy V. Whiteman; Robert L. Williams Library, Durant, Oklahoma; Tom Williams; Kim Wilson; ZZ Top; those on the Trail of Tears; and my classmates.

INTRODUCTION

The Choctaws have two origin stories involving Nanih Waya (Waiya), "the Mother Mound," located near Noxapater, Mississippi. The first tells how Nanih Waya (Waiya) gave birth to the people. First the Seminoles, then the Muscogees, then the Cherokees, then the Chickasaws, and last, the Choctaws. The other tribes all traveled to new lands, but the Choctaw remained close to the Mother Mound.

In the second story, there were two brothers Chahta and Chickasa who headed the people in a land far away in the West. During one of their migrations or travels, they carried a tree, which would lean, and each day the people would travel in the direction that the tree was leaning. They traveled east and south for some time until the tree quit leaning, and then the Chahta stopped to make their home at this location, which was Nanih Waya (Waiya) where the tree stood straight up. Chickasa disagreed and continued farther north founding a new people, the Chickasaw. From there the Chahta spread to southern Mississippi and western Alabama. The people may have numbered well over 200,000 before European conquest.

The Five Civilized Tribes was the name given to the Choctaw, Chickasaw, Cherokee, Creek (Muscogee), and Seminole Indians. In the winter of 1831, the Choctaws would be the first tribe to travel the Trail of Tears in their exodus from the area of Mississippi and Alabama into newly proclaimed Indian Territory to the west. The tribe suffered greatly while families endured or died in extreme weather and conditions. Hardships included cholera, heavy rains, malnutrition, hunger, dysentery, pneumonia, influenza, and death. During one of the removals, people arrived at Eagle (now Eagletown on the Mountain Fork River) but 200 had died. The first groups of 17,000 Choctaws were in their new lands by early 1834. In 1836, another 4,000 Choctaws joined them from Mississippi. The northern Choctaws moved by wagons to Memphis, Tennessee, then by steamboat down the Mississippi to the Arkansas River, then to Fort Smith, Arkansas. The southern Choctaw were transported to Vicksburg, Mississippi, and then traveled up the Red and Quachita (then called the Little Arkansas) Rivers to about where Camden, Arkansas, is now located. Then they were hauled in wagons or walked to Indian Territory. Many were stranded without food and died. Survivors walked to Little Rock and west to Skullyville on the Canadian River. Others were held up at Monroe, Louisiana, as guides and 300 Choctaws became lost in the swamps.

There are no photographs of the 700-mile Trail of Tears movement. Artist George Catlin met American Indians and made paintings. He visited Choctaw country in 1834, traveling with the United States Dragoons, on an expedition up the Arkansas and Red Rivers. Catlin and several of the expeditioners became ill, and about 150 dragoons died of fever. At this time Catlin rested at Fort Gibson and painted Choctaw portraits. The earliest Washington delegation photographs were made in 1852, following the Fort Laramie Treaty of 1851.

The Jena Band of Choctaw Indians evaded removal into Indian Territory and comprised about 250 members located in Jena, Louisiana. They recently received U.S. federal recognition as a tribe in 1995. The Mississippi Band of Choctaw Indians number about 8,300 and are located at the Pearl River Indian Reservation near Philadelphia, Mississippi.

Choctaw locations in the time period of 1540 to 1700 included the Ohio Valley to western Tennessee, Mississippi, Alabama, and upper portions of Louisiana. The lower Ohio Valley area was vacated due to the pressure of European arrival and settlement. The Choctaws would make revisions to an 1826 constitution, and divided into the same districts they had in Mississippi. Each was governed by a chief elected every four years by citizens of the district. The three chiefs met annually with a general council (legislative body) to make laws. From 1837 to 1855, the Chickasaws merged with them and became a fourth district. After 1855, the area in the fourth district became the independent Chickasaw Nation. Under the constitution, the principal chief was elected by the people for a two-year term. The principal chief was also referred to as governor. The first meeting of the Choctaw Tribal Council in Indian Territory was held near Tuska Homma (traditional spelling) in a log council house in 1839. The first capitol of the Choctaw Nation was then named Nanih Waya (Waiya). In 1833, a brick building, the Tuska Homma Capitol House, was built two miles northeast of the old Nanih Waya (Waiya) Council House.

From 1841 to 1843, the Choctaw council appropriated funds for three academies for boys and six for girls. All boarding schools were placed under the supervision of the different Protestant American Board for Foreign Missions. However, one of the schools for boys, Spencer Academy, remained under exclusive control of the Choctaw Council for several years. Fort Coffee Academy was one of the schools established. It was placed under the Methodist Episcopal Church. The girls department of the school was located at New Hope, about a mile from the agency at Skullyville. For several years they had been sending Choctaw boys to the Choctaw Academy in Kentucky. To replace this they decided on establishing a national academy for boys at Armstrong Academy.

The San Bois, Quachita, and Kiamichi Mountains are within the Choctaw Nation of Oklahoma. Some of the larger towns within or near the Choctaw Nation are Poteau (near Fort Smith, Arkansas), Heavener, and Broken Bow. These towns are near the Arkansas line. In the northern section are Stigler, Wilburton, Eufaula, Hartshorne, and McAlester. Kiowa, Coalgate, Atoka, Caddo, Caney, and Durant are cities along the western area. The southern area next to Texas and the Red River include Colbert, Calera, Bokchito, Bennington, Boswell, Hugo, Fort Towson, Wright City, and Idabel. Towns within the central Choctaw Nation are Tuska Homma, Talihina, Clayton, and Antlers. Many other communities once thrived during the early days of the Choctaw Nation but are not forgotten.

Area large lakes include Lake Eufaula at McAlester and Eufaula. Lake Texoma is west of Durant; Sardis Lake is located in the Yanush and Tuska Homma area; Broken Bow Lake and Quachita National Forest are near Broken Bow; and Hugo Lake is between Hugo and Fort Towson. Atoka Reservoir and McGee Creek are in the Atoka-Stringtown-Lane areas. Pine Creek is at New Ringold. A significant river is the Kiamichi, and creeks include Muddy Boggy, Clear Boggy, and Blue, which all flow into the Red River, which is the Texas-Oklahoma boundary. The southwest area of the Choctaw Nation is about 80 miles from Dallas, Texas. The Choctaws recently became the fourth-largest American Indian tribe by population in the United States, according to their recent census statistics.

Donovin Sprague
Cankahu Wankatuya-High Back Bone/Hump

One

CHAHTA TIłBANLI ISHT ANUMPA
(EARLY CHOCTAW HISTORY)

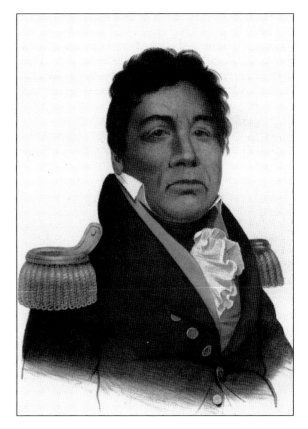

PUSHMATAHA (CHOCTAW). The Choctaw fought in the War of 1812 under Andrew Jackson, who described Pushmataha as the greatest and bravest chief he had ever known. The Choctaw resided mainly in Mississippi and Alabama, and in 1540, Spanish explorer Hernando De Soto recorded contact with them. Choctaw locations from 1540 to 1700 included the lower Ohio Valley to western Tennessee and upper Louisiana. (Sketch courtesy of Bureau of Ethnology.)

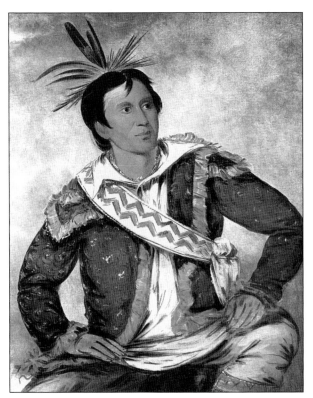

SNAPPING TURTLE, PETER PITCHCHLYNN (CHOCTAW). This is a sketch done by George Catlin in 1834. Snapping Turtle provided Catlin with historic information about the Choctaw. He was a well-educated leader and was known to non-Indians as Peter Pinchlin. (Courtesy of Bureau of Ethnology.)

BENJAMIN F. SMALLWOOD (CHOCTAW). Benjamin F. Smallwood was born around 1829 in Mississippi and emigrated with his people to the Choctaw Nation. His parents were Elisha Smallwood and Mary LeFlore. In 1849, he married Annie Burney, a Chickasaw of the house of Ima-te-po. He defeated Wilson N. Jones in an election to became principal chief of the Choctaw Nation. He died in 1891 at Lehigh. (Courtesy of Confederate Memorial Museum and Oklahoma Historical Society.)

SAMPSON FOLSOM (CHOCTAW).
Sampson Folsom was born in 1820
in Mississippi and lived at Moose
Prairie near Easedale, Choctaw
Nation. He married Catherine
Colbert in 1842. Col. Sampson
Folsom raised the first battalion to
serve the Confederates. He served as
a delegate to George Washington for
both the Choctaw and Chickasaw
Nations. In 1866, he was a Choctaw
national attorney. Folsom died near
Doaksville in 1872. This photograph
was taken by A. Zeno Shindler
in 1868. (Photograph courtesy of
Bureau of Ethnology.)

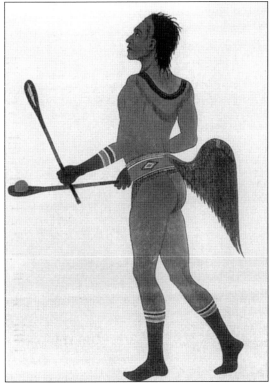

**DRINKS THE JUICE OF THE STONE
(CHOCTAW).** This 1834 sketch shows
a ballplayer wearing the official regalia
of the stickball game based on a sketch
by Catlin. The tail and cape are made
from horsehair. Drinks the Juice of
the Stone was described by Catlin as
the most outstanding ballplayer of the
tribe. (Sketch courtesy of Bureau
of Ethnology.)

11

CHUCALISSA INDIAN VILLAGE. This village at Memphis, Tennessee, has yielded important archaeological artifacts, including pottery, jewelry, weapons, and tools. Reenactments are held at this reconstructed village site built on the actual archaeological site of this 15th-century village. The Charles H. Nash Museum is a living museum and has close connection to the Choctaw Nation and the University of Memphis. *Chucalissa* means "abandoned house" in the Choctaw language. (Courtesy of Donovin Sprague, 2003.)

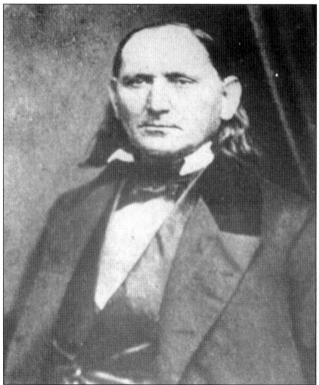

PETER PERKINS PITCHLYNN (CHOCTAW-ENGLISH). Peter Perkins Pitchlynn was born in a settlement called Shik-o-pok (the Plume) in Nuxubee County, Mississippi, on January 30, 1806. His father was an Englishman, Maj. John Pitchlynn, and his mother, Sophia Folsom (She-na-ka), was one-half Choctaw. Peter was elected principal chief in 1860. After the death of his first wife, Rhoda Folsom, he married Caroline Lombardy in Washington, D.C. He died in 1881 and is buried in Congressional Cemetery in Washington, D.C. (Courtesy of Tommy V. Whiteman.)

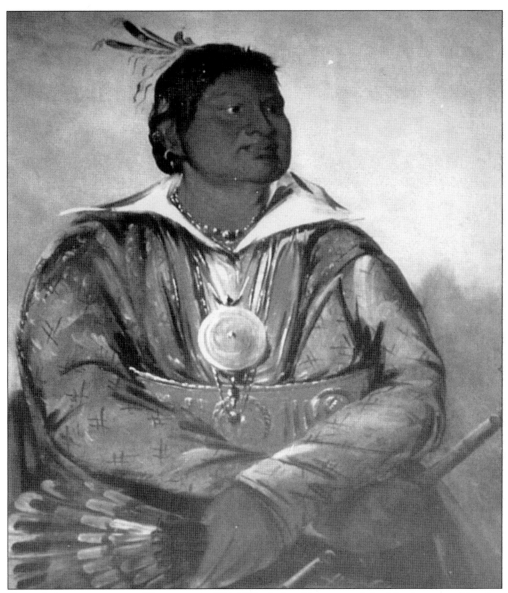

CHIEF MOSHOLATUBBEE (CHOCTAW). Chief Mosholatubbee was of the Northeastern District, Choctaw Nation, in Mississippi; he received his name as a young warrior. It comes from the word *Amosholi-T-Vbi*, "Warrior Who Perseveres." He was born in 1770 and as a leader was known for banning liquor traffic. A mission school (ABCDFM) was located at his village near the Natchez Trace in 1824. He was one of the head chiefs who signed the early Choctaw treaties with the United States, including the Treaty of Dancing Rabbit Creek in 1830, for Choctaw removal from Mississippi. He relocated to Indian Territory off the Fort Towson Road, north of Sugar Loaf Mountain. Near this area in 1836 was a Baptist mission school. Mosholatubbee died at his prairie home by Sugar Loaf Mountain in 1838, his grave covered with unmarked stones. (Portrait by George Catlin, 1834; courtesy of Bureau of Ethnology.)

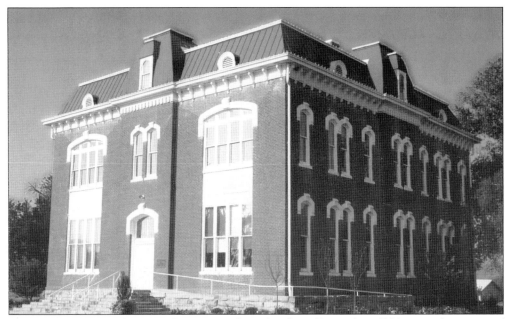

CHOCTAW NATION CAPITOL BUILDING. Completed in September 1884 near the town of Tuskahoma in Pushmataha County, the building was constructed of red native brick, sandstone, and nearby timber at a cost of $30,000. It has housed the tribe's senate, house of representatives, supreme court, and offices for the principal chief. Today it is a museum and gift shop and houses the Choctaw Nation Judicial Department and Court. (Courtesy of Choctaw Nation of Oklahoma.)

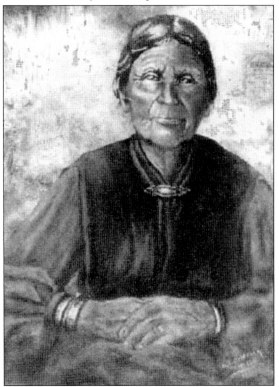

SOPHIA FOLSOM PITCHLYNN (CHOCTAW). Sophia Folsom Pitchlynn's Choctaw name was She-Na-ka; she was born in Mississippi around 1784, where she followed the Presbyterian worship of Cyrus Byington. She died at about the age of 87 in McCurtain County, Indian Territory. Sophia married John Pitchlynn, and when he died in 1835, she moved to Indian Territory where she settled about six miles from the Arkansas line. She had African American slaves and raised cotton, corn, and melons. (Painting courtesy of Tommy V. Whiteman.)

HENRY CHURCHILL HARRIS. Born in Eagle County, Choctaw Nation, in 1837, Henry Churchill Harris attended a private school until 1856 and then went to Armstrong Academy. During the Civil War he joined the Confederate army for three years. Following his discharge, he returned to Red River County and engaged in farming and raising livestock. In 1863, he married Margaret Elizabeth Lee (known as "Maggie") of Arkansas. In 1888, he was selected as supreme judge to fill the unexpired term of A. R. Durant. Harris was about one-sixteenth Choctaw, and a nephew of Chief Peter P. Pitchlynn. Harris died in 1899 at Pleasant Hill, Indian Territory. (Courtesy of Tommy V. Whiteman.)

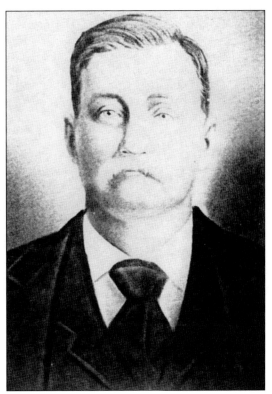

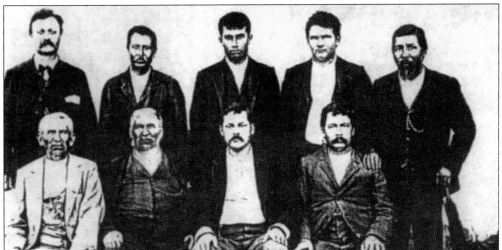

CHOCTAW NATIONAL EDUCATION COMMISSION. Pictured at Wheelock in McCurtain County, from left to right are (first row) John Turnbull, Henry Harris, John Wilson, and Willie Wilson; (second row) Wood Kirk, Absolum James, Edward Wilson, Raphael Wilson, and Solomon Hotema. Wood Kirk came from Virginia in 1872. In 1896, Absolum James was district judge of the Apukshunnubbi District. Edward Wilson was superintendent of Wheelock Seminary. Raphael Wilson served under Oklahoma governor Haskell. Solomon Hotema took up ministry and politics, but killed two Choctaw women and a man who he accused of witchcraft. He went to prison in Atlanta, Georgia, where he died in 1907. (Courtesy of Choctaw Nation of Oklahoma, 1892.)

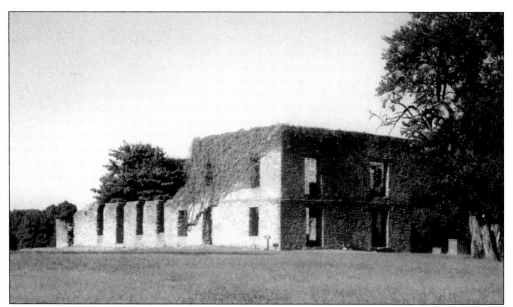

FORT WASHITA. Established in 1842, the post of Fort Washita was to protect Chickasaw and Choctaw Indians from the Plains Indians. The Removal Act put these tribes into conflict with tribes who had occupied the area before. Fort Washita was occupied by Confederate forces and used during the Civil War. This is the West Barracks area of Fort Washita, which was built in 1856 of native limestone. Abandoned after the Civil War, the fort provided a home for the Colbert family until it was destroyed by fire in 1917. (Courtesy of Donovin Sprague.)

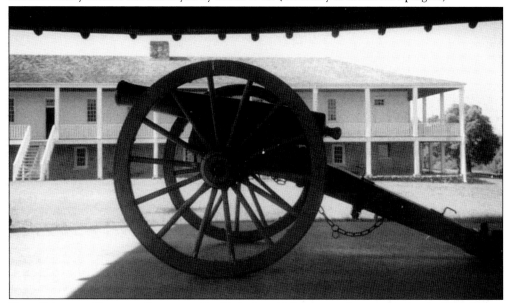

FORT WASHITA CANNON PAVILION. Established in 1842 to provide quarters for the U.S. Indian Agency, Fort Washita was abandoned by U.S. forces on April 16, 1861. The next day, the Confederate forces occupied it and used it during the Civil War. The fort was acquired by the Oklahoma Historical Society in 1962. Pictured here is the cannon pavilion. In 1853, only one battery of light artillery was assigned to the post. This one is a Napoleon 12-pound howitzer, which was widely used in the U.S. Civil War. It had a maximum range of 1,680 yards. (Courtesy of Donovin Sprague.)

Two

CHAHTA OKLA HATTAK VPI HUMMA I YAKNI
(CHOCTAW NATION INDIANS THEIR LAND)

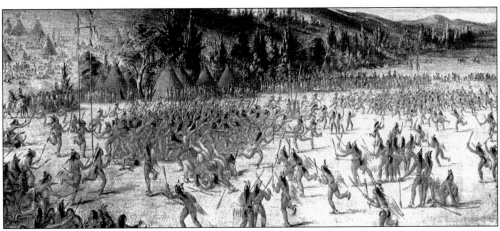

CHOCTAW LACROSSE GAME. Under the 1820 Treaty of Doaks Stand, the tribe ceded 4.15 million acres of land to the United States. Mississippi entered the union in 1817, and pressure was on to take all Choctaw land. The tribe would be removed under the Treaty of Dancing Rabbit Creek of September 20, 1830, to Indian Territory in present Oklahoma. (Sketch by George Catlin from 1834 to 1835; courtesy of Bureau of Ethnology.)

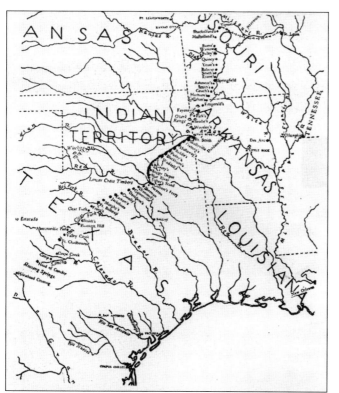

BUTTERFIELD STAGE ROUTE. Butterfield Overland Mail Company was awarded a contract in 1857 for mail service. A highlighted section shows the route from Fort Smith, Arkansas, to Colbert's Ferry on the Red River. It was the longest stagecoach route in the world, a total of 2,800 miles. Later events along this route included raids by gangs such as Jesse James's. In 1932, Clyde Barrow, Raymond Hamilton, and possibly more of the Bonnie and Clyde gang shot Atoka County sheriff Charlie Maxwell and his deputy, Eugene Moore, at String Town. Moore died instantly. Maxwell was shot seven times but survived. (Courtesy of Choctaw Nation of Oklahoma and Oklahoma Historical Society.)

EMILY MISHAYA BILLY (CHOCTAW). Emily Mishaya married Isaac Billy, and the photograph was taken in front of the Billy homestead, which was founded in 1879 and was located at Many Springs Court Ground Community of Jackfork County of the old Choctaw Nation in Indian Territory. (Courtesy of Tom Williams, around 1908.)

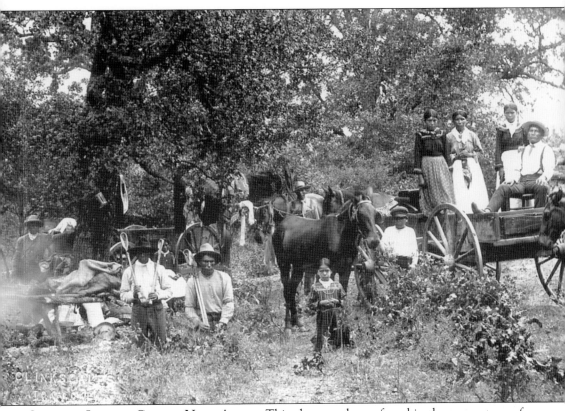

CHOCTAW INDIANS CAMPED NEAR ATOKA. This photograph was found in the cornerstone of the Atoka County Courthouse, built in 1913. It reads on the back, "Choctaw Indians camped near Atoka, Okla., showing Indian baseball clubs" (stickball). The photograph was donated by Gwen Walker. (Photograph by Clinkscales around 1913; courtesy of Confederate Memorial Museum.)

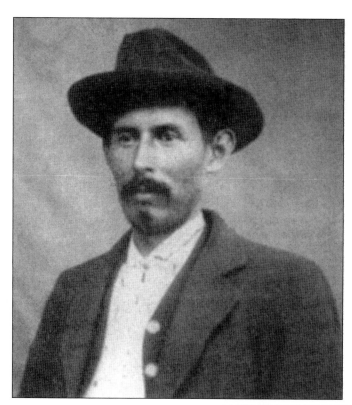

JEFFERSON GARDNER (CHOCTAW). Jefferson Gardner was chief of the Choctaws from 1894 to 1896. He was born in 1847 in Wheelock, Towson, Indian Territory. His parents were Noel Gardner and Henritta (Hannah/Harriet) LeFlore. Noel traveled on the Trail of Tears with his five brothers to Eagletown, and his wife, then Ms. LeFlore, was the daughter of Capt. Thomas LeFlore and Shakapahona "Sookie" Pusley. Jefferson died in Idabel, Oklahoma, in 1906, and rests in Eagletown. (Courtesy of Bureau of Ethnology.)

GREEN MCCURTAIN (CHOCTAW). Green (or possibly Greenwood) McCurtain was born near Skullyville in 1848 and was chief of the Choctaws from 1896 to 1900 and 1902 to 1910. The family had a political dynasty; older brothers Jackson Frazier and Edmund McCurtain were also chiefs. Green married Martha A. Ainsworth and then married Kate Spring. Family brothers were Daniel, Thomas, John, Luke, Allen, William, Canada, and Samuel; the brothers Cornelius, Samuel, and Camper all enrolled at the Choctaw Academy in Kentucky. (Courtesy of Bureau of Ethnology.)

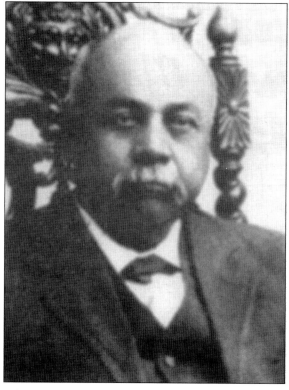

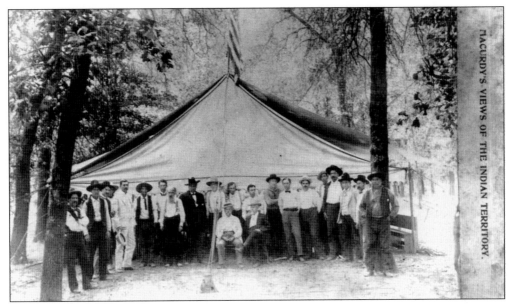

DAWES COMMISSION AT LEHIGH. Taken by Macurdy, this photograph shows the Dawes Commission meeting at Lehigh, Indian Territory. Lehigh was the county seat of Coal County from Oklahoma statehood until 1908. Its name comes from Lehigh, Pennsylvania. Nearby Coalgate became the new county seat at that time. Coalgate was first known as Liddle and took its new name in 1890 from the nearby coal mines. (Courtesy of Confederate Memorial Museum and Oklahoma Historical Society.)

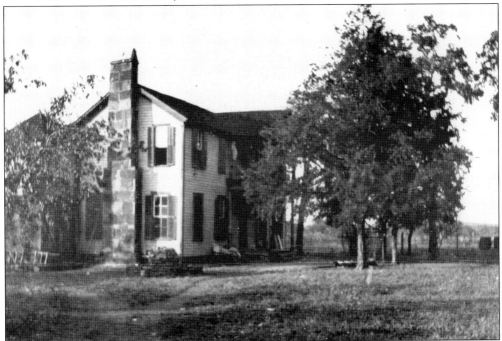

CHARLES LEFLORE RESIDENCE. This is the two-story home of Charles LeFlore, who lived near Limestone Gap. This photograph was taken between 1896 and 1902. (Courtesy of Confederate Memorial Museum and Oklahoma Historical Society.)

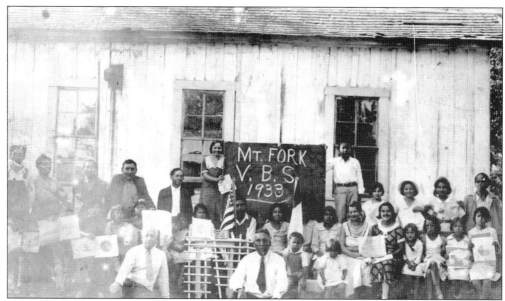

MOUNT FORK CHURCH, EAGLETOWN, OKLAHOMA. This picture belonged to Lena Bohanon Hicks of Eagletown (Osi Tamaha) and Broken Bow, Oklahoma. She was a member of the church who passed away in 2005. John Bohanon was the minister at the Mount Fork Church until he passed away. Lena's son was Wilson Amos Tonihka, and both were born in Eagletown. When Wilson passed away his services were held here at Mount Fork Church. (Courtesy of Elizabeth Tonihka McKinney, 1933.)

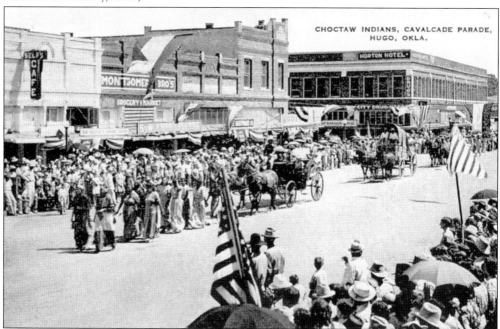

HUGO, OKLAHOMA, PARADE. This postcard shows Choctaw Indians in the Cavalcade Parade in Hugo, Oklahoma. It is postmarked from Hugo in 1943. Some of the business names on the buildings include Self's Café, Montgomery Brothers, Benedict Shoe Shop, S&W Food Market, and Horton Hotel. (Courtesy of Donovin Sprague.)

Three

OKLAHOMA
CHAHTA OKLA
(CHOCTAW NATION OF OKLAHOMA)

LEROY GARDNER (CHOCTAW). Leroy Gardner was born two miles east of Armstrong Academy in Blue County, Pushmataha District, in 1901. His parents were Samuel G. Gardner and Florence Gardner. The territory was opened to white settlers under the Oklahoma Land Rush of 1889, for more native land and resources. A census was done for Oklahoma Territory in 1900, and in 1907, Oklahoma became a state. (Courtesy of Choctaw Nation of Oklahoma.)

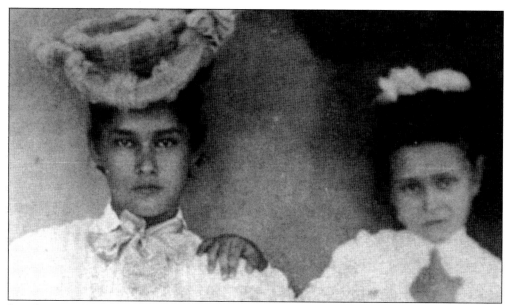

IDA AUSTIN WHITFIELD AND NELL AUSTIN PRUITT (CHOCTAW). Ida Austin Whitfield (with hat) was born in 1890 to Levicey Garland Austin and Henry Austin and lived in the Valliant area. Ida attended Wheelock Academy and married John Whitfield in 1906. Ida was a kind and religious woman, and hummingbirds would land on her outstretched hands. She passed away in 1948 and is buried at Valliant. Nell Austin Pruitt was Ida's niece. (Courtesy of Choctaw Nation of Oklahoma and Oklahoma Historical Society.)

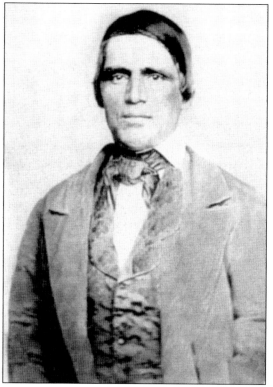

FORBIS LEFLORE (CHOCTAW). Forbis LeFlore was born in 1810 on LeFleur's Bluff, Pearl River, in the Choctaw Nation of Mississippi Territory. He was the youngest son of Louis LeFlore (French), who emigrated to Mobile, Alabama. In 1832, Forbis married Sinai Hayes, daughter of Captain Hayes, one of the leaders of a band of Choctaws who traveled the Trail of Tears. Forbis ran a store at Doaksville in the new Indian Territory. At Buffalo Head, Forbis became superintendent of schools, practiced law, and served as a judge. (Courtesy of Dina Deupree.)

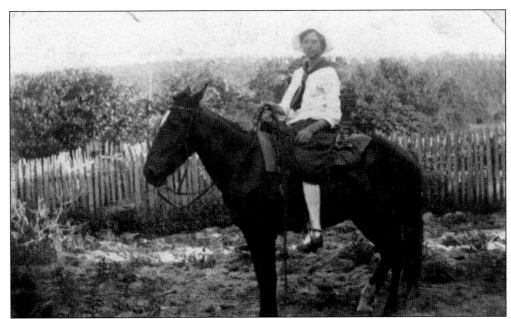

MINNIE BRIGGS (CHOCTAW). Minnie Briggs is on the Dawes Roll at No. 2532, and her mother's name was Jennie Briggs. The Dawes Final Roll shows Minnie as being one year old and one-sixteenth Choctaw, and residing in Whitefield, Oklahoma. Minnie is the great-aunt of Randie Ary Graves of Broken Arrow, Oklahoma. Minnie is the half sister to Mary Rebecca Briggs Ary. (Courtesy of Randie Ary Graves.)

DOLLIE MAE BILLY, EMILY MISHAYA BILLY, AND MYRTLE EMILY BYINGTON (CHOCTAW). This c. 1917 picture was taken at the Billy homestead. Emily's daughter is Dollie Mae (left), who was later the wife of James Peters, and her second husband was Pollie Beal. Myrtle Byington (right) is the granddaughter of Emily Billy. Myrtle married Bert Williams. (Courtesy of Tom Williams.)

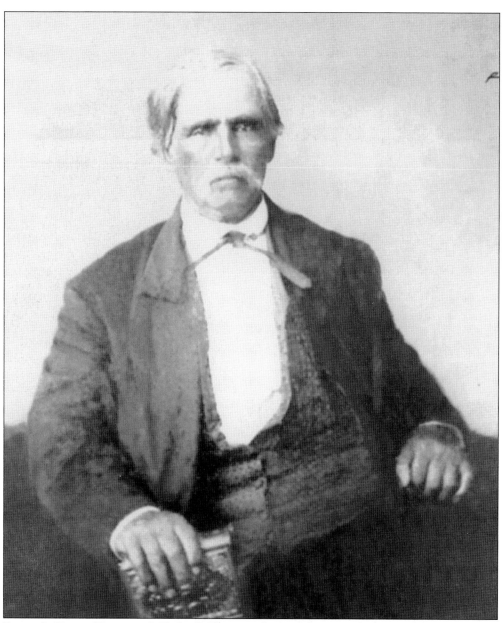

FORBIS LEFLORE (CHOCTAW). Forbis LeFlore was the son of Louis and Nancy LeFlore. His father, Major LeFlore, was born in 1762 in Mobile, West Florida. The major died around 1833 in Hot Springs, Arkansas, and was buried in Yazoo Valley, Holmes, Mississippi. He died soon after the last treaty with the Choctaws. Major LeFlore's parents were Jean Baptiste LeFleur (LeFleau) and Marie Jeanne Girard. The major married Nancy Cravat about 1790, and married Rebecca Cravat about 1792, both in Mississippi. He also married Ho-ke Chickasaw about 1793. His children with Rebecca Cravat were Benjamin LeFlore, Santiago Mathius LeFleur, Sylvia LeFlore, Felice "Felicity" LeFlore, Chief Col. Greenwood LeFlore, Isabella Emily "Sibell" LeFlore, William LeFlore, Basil LeFlore, and Jackson LeFleur. His children with Nancy Cravat were Louisa LeFlore, Clarissa LeFlore, Winna "Winnie" LeFleur, Tobias "Toby" LeFleur, and Forbis LeFlore. His children with Ho-ke were Margarita LeFleur and Marie LeFleur. (Courtesy of Dina Deupree.)

MATILDA ELIZABETH LeFLORE MANNING (CHOCTAW). Matilda was born on April 14, 1838 or 1839, at Doaksville, Towson County, Apukshunubee District, Choctaw Nation of Indian Territory (later Oklahoma). She married Dr. Thomas Jefferson Manning Jr. on April 27, 1857, in Fannin County, Texas. Matilda died on December 26, 1930, at the Confederate Home in Carter County, Ardmore, Oklahoma. (Courtesy of Dina Deupree.)

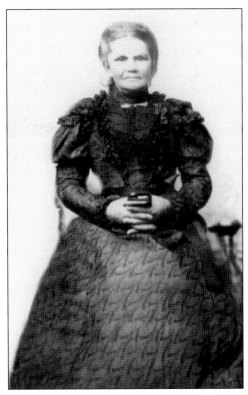

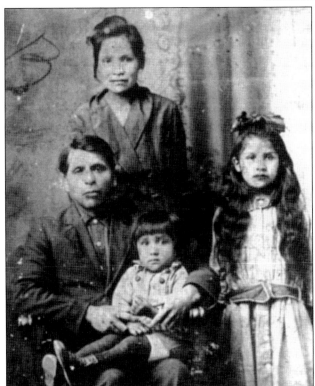

AGNES LEWIS AND NELSON JACOB (CHOCTAW). In this c. 1917 photograph, Agnes Lewis stands at left, and Mary (Jacob) Hicks is at right. Nelson holds his son Calvin. Nelson married Agnes and they had six children. Nelson was born in 1876 and was a farmer and a preacher. He died in 1946 and is buried at the Bentley Cemetery. His grave is unmarked, behind his sons who are also buried there. Agnes was born in 1883; she went to boarding school at age seven as required. (Courtesy of Choctaw Nation of Oklahoma.)

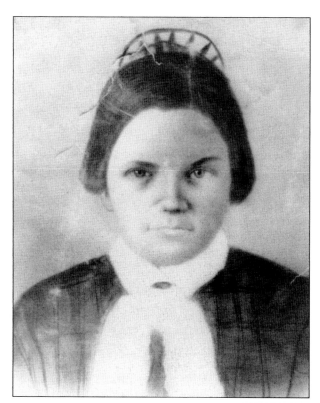

MATILDA ELIZABETH LEFLORE MANNING (CHOCTAW). Matilda Elizabeth LeFlore Manning was born at Doaksville, Indian Territory, in 1838 or 1839, and was 18 years old in this *c.* 1856 photograph. (Courtesy of Dina Deupree.)

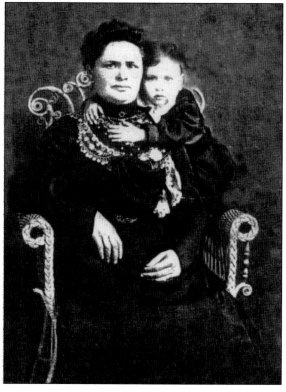

ANGELINE REBECCA MANNING AND SON CLARENCE C. FOX (CHOCTAW). Angeline Rebecca Manning was born on May 31, 1861, at Boggy Depot, Blue County, Choctaw Nation of Indian Territory (later Oklahoma). She married William Riley Fox at Caddo, Blue County, Indian Territory, and their son Clarence C. Fox was born in 1882 at Snowhannich, Washington Territory. Angeline died on September 17, 1926, and was buried at Rose Hill Cemetery in Oklahoma City. (Courtesy of Dina Deupree.)

REV. ISRAEL FOLSOM (CHOCTAW).
Rev. Israel Folsom was the father of
several children, one of whom was
Judge Julius C. Folsom. Israel and
his wife, Lovica Nail Folsom, lived
at Boggy Depot where they are both
buried. Rev. Folsom died on April 24,
1870, and Lovica died on July 11, 1876.
(Courtesy of Confederate Memorial
Museum and David C. Steed.)

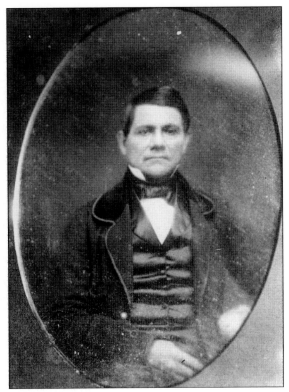

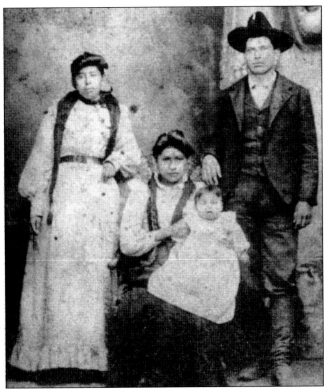

**THE DANDRIGE FAMILY
(CHOCTAW).** Pictured from
left to right are William A.
Dandridge's sister-in-law,
Elsie; Sarah Dandridge;
daughter Martha Dandridge;
and William A. Dandridge.
William A. (W. A.)
Dandridge was born in Mena,
Arkansas, in 1880. His father,
James, moved the family to
Bonham, Texas, and then
moved to Calvin Allison's
place near Boggy Depot,
Indian Territory. Following
the death of his wife Sarah
in 1913, W. A. Dandridge
married Czarina Homer about
1917. W. A. died at age 81 in
1962. (Courtesy of Choctaw
Nation of Oklahoma and
Oklahoma Historical Society.)

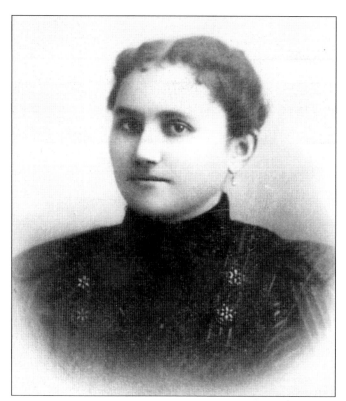

CHICKIE LEFLORE CRUSE (CHOCTAW). Chickie LeFlore Cruse was one of the twin daughters born to Capt. Charles LeFlore and his wife, Mary Angelina. Mary Angelina was a daughter of Col. William R. Guy. Chickie married Lee Cruse, Oklahoma's second governor. They were married in the two-story LeFlore home, which was located at Limestone Gap in Atoka County. (Courtesy of Confederate Memorial Museum and Oklahoma Historical Society.)

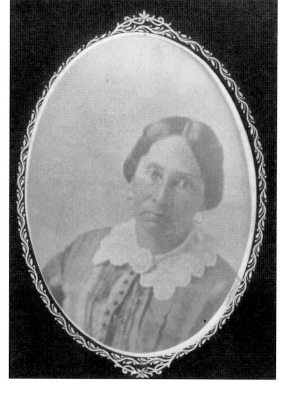

LOVICA NAIL FOLSOM (CHOCTAW). Lovica Nail married Rev. Israel Folsom, and they lived at Boggy Depot, Indian Territory. She was the mother of Judge Julius C. Folsom. (Courtesy of Confederate Memorial Museum and David C. Steed.)

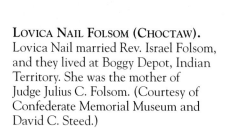

CHOCKIE LEFLORE (CHOCTAW). Chockie LeFlore was one of twin daughters born to Capt. Charles LeFlore and his wife, Mary Angelina. Chockie, Oklahoma, is named for Chockie LeFlore. The town was first known as Rich and was then named Chickie-Chockie for the LeFlore twins. When Chickie died they dropped her name and it became Chockie. (Courtesy of Confederate Memorial Museum and Oklahoma Historical Society.)

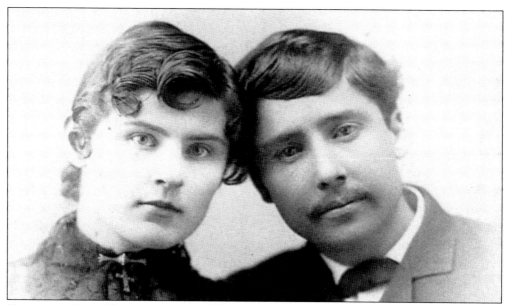

HENRIETTA CLAY HUME JUZAN AND HUSBAND ALEXANDER JUZAN (CHOCTAW). Henrietta Clay Hume was born in 1863 and Alexander Juzan in 1855. Henrietta married Alexander against her parents' wishes. According to family history, Alexander was killed in 1887 by Mardwick of the Indian police while they were trying to arrest him. Henrietta later married Walter Colbert in 1896 and was the grandmother of David C. Steed, who provided the photograph. Henrietta died in 1942. (Courtesy of Confederate Memorial Museum and David C. Steed.)

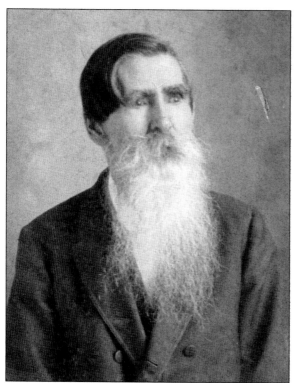

REV. R. J. HOGUE. Rev. R. J. Hogue was born in Green County, Georgia, on March 8, 1820, and came to Indian Territory in 1857. He was a minister at the Boggy Depot and Atoka areas for many years. He married Clarissa Jenkins, and their daughter was Teresi T. Inge. He died in 1906 at age 86, and Clarissa preceded him when she passed away in 1902. (Courtesy of Confederate Memorial Museum and David C. Steed.)

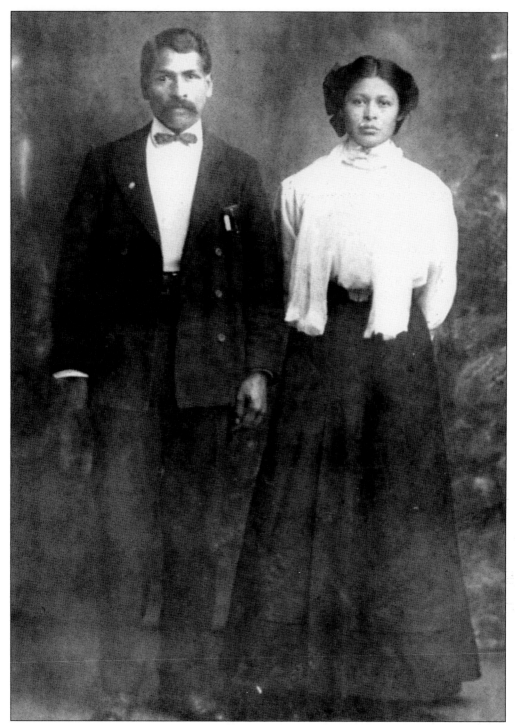

Mr. and Mrs. Lincoln Ishcomer (Choctaw). This photograph was taken in Atoka sometime between 1908 and 1915. Mr. Ishcomer was a Choctaw Methodist worker in the area. (Photograph by W. W. Clinkscales; courtesy of Confederate Memorial Museum, the Oklahoma Historical Society, and C. M. Coppage.)

HARRIET "HATTIE" ATHENIUS McBRIDE (CHOCTAW). Harriet "Hattie" Athenius McBride was the daughter of Hiram Young and Lovica Folsom McBride. She was born in Atoka on February 16, 1889, and died on January 29, 1980. Hattie was the second of 10 children in the family. (Courtesy of Confederate Memorial Museum and David C. Steed, 1880.)

LOVICA COLBERT MCBRIDE (CHOCTAW). Lovica Colbert McBride was born on August 2, 1868, in Colbert, Indian Territory, and married Hiram Young McBride on February 24, 1886. Her parents were James Colbert and Athenius Folsom Colbert. The McBrides had nine children, and Lovica died in 1963. (Courtesy of Confederate Memorial Museum and David C. Steed.)

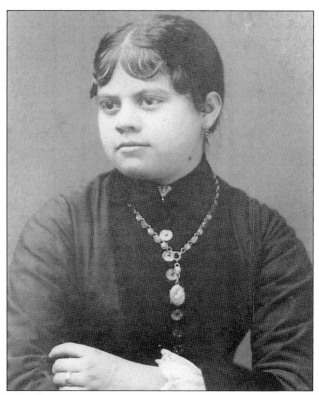

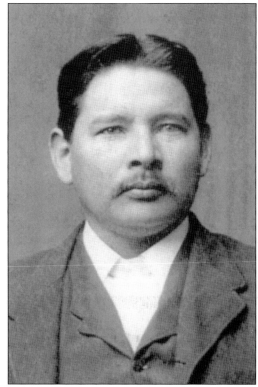

NOAH PAYTON (CHOCTAW). Noah Payton lived in the community of Bentley, Oklahoma, and was the father of Joseph N. Payton and Anna Mae (Payton) Redden. (Courtesy of Confederate Memorial Museum.)

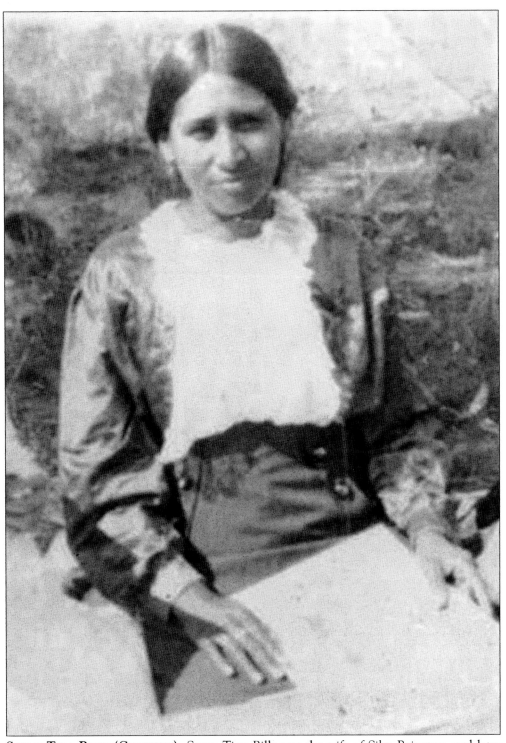

Susan Tina Billy (Choctaw). Susan Tina Billy was the wife of Silas Byington, and later married A. G. Brummitt. (Courtesy of Tom Williams, around 1916.)

CYRUS KINGSBURY. Rev. Cyrus Kingsbury was a leader of the Presbyterian missionaries to the Choctaw and Chickasaw Indians. In 1840, he and Rev. Ebenezer Hotchkins organized the first church at Boggy Depot, Indian Territory. Cyrus was the father of John Kingsbury, founder of the *Choctaw and Chickasaw Observer* newspaper at Boggy Depot. Cyrus died in Boggy Depot on June 27, 1870, at age 83. He was known to the Choctaws as Limping Wolf because of his lameness. (Courtesy of Confederate Memorial Museum and Oklahoma Historical Society.)

FR. ISADORE ROBOT. The first Catholic church in Indian Territory was built in Atoka. Fr. Isadore Robot was its first resident priest. (Courtesy of Confederate Memorial Museum and Oklahoma Historical Society.)

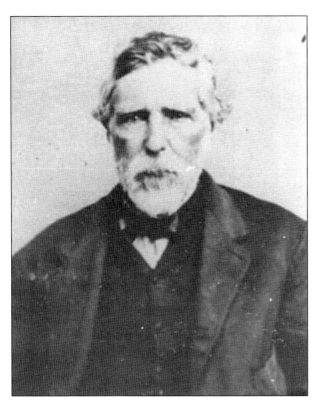

SAMUEL GARLAND. The son of John Garland, Samuel was born in Jasper County, Mississippi, in 1803. He was educated at the Choctaw Academy in Kentucky and then returned to Mississippi and married Mary Pitchlynn, daughter of Maj. John Pitchlynn and Sophia Folsom. John Garland I, son Samuel Garland, and Peter P. Pitchlynn were the principal negotiation committee for the Dancing Rabbit Treaty. Samuel built a home on 600 acres of Red River bottom land with a plantation and African American slaves. He was chief of the Choctaws from 1862 to 1864. (Courtesy of Bureau of Ethnology.)

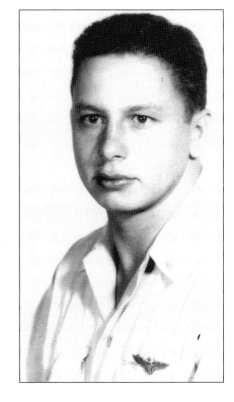

OSCAR FOLSOM JR. (CHOCTAW). Born in 1922 in Caney, Oklahoma, to Oscar Folsom Sr. and Blanche Ballard Folsom, Oscar Folsom Jr. graduated from Atoka High School in 1940 and attended Murray State School of Agriculture at Tishomingo from 1940 through 1942. He made a career in the U.S. Navy from 1942 to 1963. He retired with the rank of lieutenant commander and was the first naval aviator from Atoka County. He died at the age of 81 in Norman, Oklahoma, in 2003. (Courtesy of Confederate Memorial Museum.)

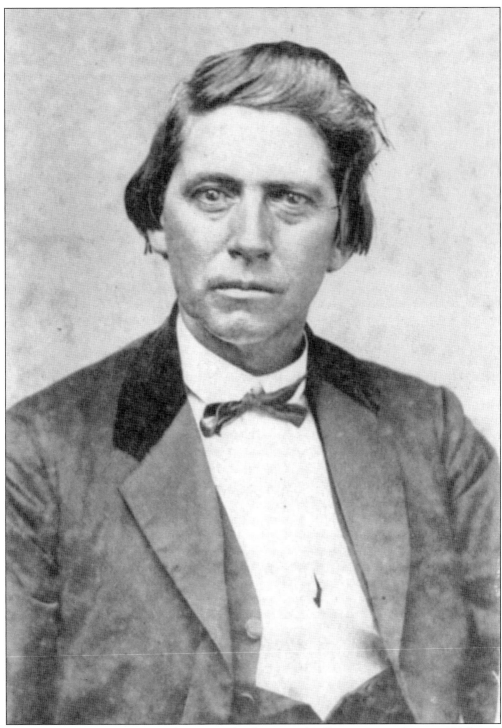

BENJAMIN FRANKLIN COLBERT (CHOCTAW). The town of Colbert in Bryan County, Oklahoma, is named for the family of Benjamin Franklin Colbert. (Courtesy of Confederate Memorial Museum and David C. Steed.)

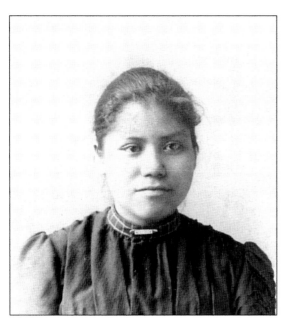

FRANCES WILLIAMS SCHROCK (CHOCTAW). Frances Williams Schrock was a full-blood Choctaw who was orphaned. She was raised by Hiram Y. and Lovica Colbert McBride. She is listed as a student at the Atoka Baptist Academy in 1893–1894. She had a sister named Sallie, and Frances later married Mr. Schrock. At the time of the Choctaw enrollment, a son, Arthur Lee, was also listed and enrolled with her. (Courtesy of Confederate Memorial Museum and David C. Steed, May 1894.)

SUSAN FOLSOM BYRD (CHOCTAW). Susan Folsom was the daughter of David Folsom, who was a governor of the Choctaw Nation. She married William L. Byrd in 1862, and he served as governor of the Chickasaw Nation. They had no children. (Courtesy of Confederate Memorial Museum and David C. Steed.)

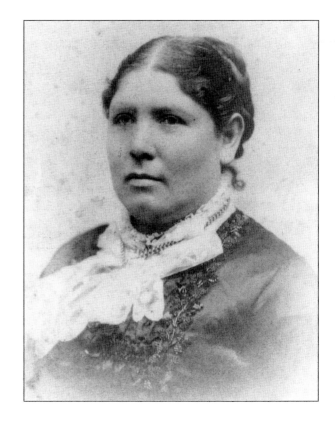

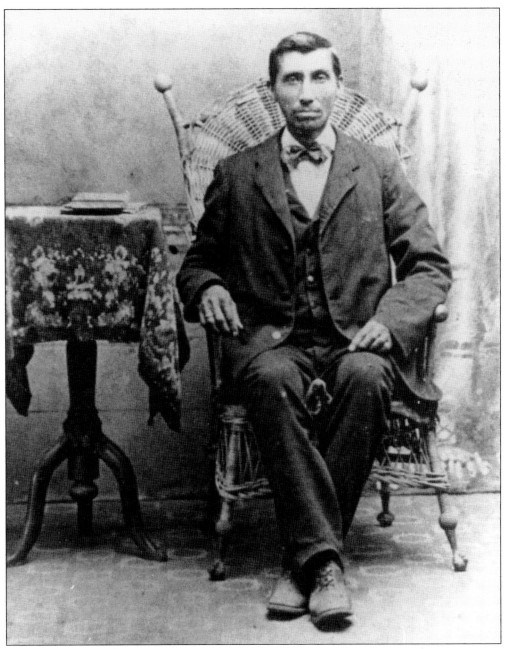

ISAAC A. BILLY (CHOCTAW). Isaac A. Billy was a full-blood Choctaw who was born on June 4, 1859, some four miles east of Daisy, Oklahoma, which was Indian Territory at that time. He attended Spencer Academy and entered the teaching profession. He also served as county judge, county clerk, and sheriff in Jack's Fork County. He served as representative of Jack's Fork County to the Choctaw Council in Tuska Homma. Jack's Fork County is now the Daisy area. Isaac Billy married Emily Mishaya, who was born near Doaksville, and they had 16 children. Billy died on August 11, 1910, and is buried in a family cemetery near his home at Daisy. (Courtesy of Confederate Memorial Museum.)

ELIZABETH HODGES CLINE (CHOCTAW). Elizabeth Hodges was the daughter of Joseph and Amanda Hodges, and a sister of John M. Hodges, Joseph J. Hodges, and David "IW" Hodges. She was born in 1872 and married John Arthur Cline at the home of brother John M. Hodges on March 30, 1892. Elizabeth died on August 15, 1939. (Courtesy of Confederate Memorial Museum and David C. Steed.)

ATHENIUS FOLSOM COLBERT (CHOCTAW). Athenius Folsom was born on August 11, 1835, at Eagletown in the Choctaw Nation. She was the daughter of Rev. Israel Folsom. Athenius married James Allen Colbert when she was 18. Prior to her marriage, the family lived at Fort Washita, where it was reported that Athenius and her sister Czarina Folsom were the most beautiful girls at the fort. (Courtesy of Confederate Memorial Museum and David C. Steed, April 1926.)

ELIZABETH HODGES CLINE (CHOCTAW).
Elizabeth Hodges was born on July 16, 1872, at Lukfata, Indian Territory, to J. J. Hodges and Amanda Hodges. She married Arthur John Cline in Atoka on March 30, 1892. Elizabeth died in Durant on August 15, 1939, and is buried in the Westview Cemetery in Atoka, along with both of her parents. The photograph was provided by John Victor Cline of Houston, Texas. (Courtesy of Confederate Memorial Museum.)

DR. THOMAS J. BOND (CHOCTAW).
Dr. Thomas J. Bond was the first Choctaw with accredited training as a doctor of medicine, and became a surgeon in the Confederate army. He cared for the wounded at Boggy Depot. Thomas was born on June 16, 1829, the son of Rebecca Juzan Bond and a nephew of Eliza Ann Flack. He died on March 31, 1878, at the age of 48. (Courtesy of Confederate Memorial Museum and David C. Steed.)

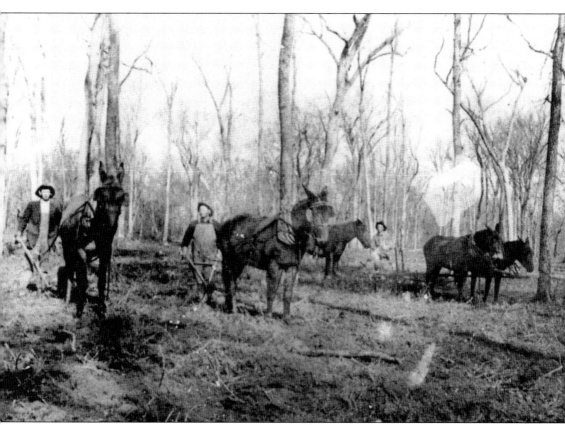

WALLACE WILLIAM BETTS AND SON CLYDE W. BETTS (CHOCTAW). In this c. 1910 photograph, the man on the left is unidentified, in the center is Wallace William Betts, and on the right is his son Clyde W. Betts. The Betts family is busy clearing their original allotment land, and as late as 2000 they were one of the few families still occupying their original allotment land. The photograph was provided by Dwight Betts of Dallas, Texas. (Courtesy of Confederate Memorial Museum.)

ELIZA ANN JUZAN FLACK. Eliza Ann Juzan Flack was a pioneer settler in Atoka, Indian Territory. She owned the original land where Atoka now sits. Her father was Charles Juzan (French/Choctaw), and her mother was Peggy Traherne. Eliza Ann's grandmother Shanke was the daughter of Natona, the sister of Chief Pushmataha of the Choctaw. Eliza married Hugh C. Flack, who was born in Kentucky, and they had six children. Eliza Ann lived until 1890 when she passed away at age 71 or 72. (Courtesy of Confederate Memorial Museum and Oklahoma Historical Society.)

CZARINA COLBERT CONLAN (CHOCTAW). Czarina Colbert was the daughter of James Allen Colbert and Athenius Folsom Colbert, and the granddaughter of Israel Folsom. Czarina was married to Michael Conlan on November 6, 1894, by Rev. J. S. Murrow in Atoka. She established the Pioneer Club in Atoka and later ran for state commissioner of corrections. (Courtesy of Confederate Memorial Museum and David C. Steed.)

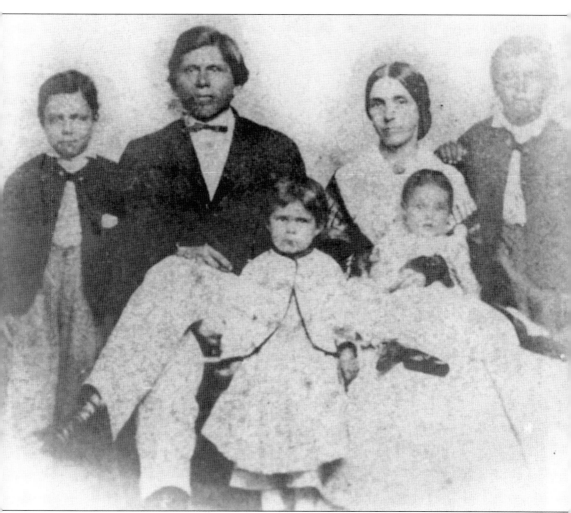

CHIEF ALLEN WRIGHT AND FAMILY (CHOCTAW). Born in 1826 in Mississippi, Allen Wright came to Indian Territory on the Trail of Tears with his parents. His mother died on this trail. He had two brothers and a sister. When his father died a few years later, the children were taken in by missionaries. Wright's Choctaw name was Kilihote. He made his first home with Rev. Cyrus Kingsbury. Wright originally spoke only Choctaw but learned English, Latin, Greek, and Hebrew. He attended several colleges in the East, then returned to the Choctaw Nation and was ordained as a preacher. In 1857, he married Harriet Newell Mitchell. While serving on the Delegation of 1866, he was elected principal chief/governor of the Choctaw Nation. He died of pneumonia at age 59 in 1885, and Harriet died soon after. (Courtesy of Confederate Memorial Museum and Oklahoma Historical Society, late 1860s.)

**KATHERINE "KATE" HARKINS
McCLENDON (CHOCTAW).** Katherine
"Kate" Harkins was the daughter of
Alonzo J. and Nancy J. Harkins. Kate
married Dr. James Wesley McClendon.
Kate was known for her outstanding
soprano voice, and in 1910, she traveled
to Paris, France, where she studied with
the renowned voice teacher Prof. Jane
DeRiski. James and Kate McClendon
later moved to McAlester, Oklahoma.
Kate died in 1944, and all of the above
family are buried at Atoka. (Courtesy
of Confederate Memorial Museum and
David C. Steed.)

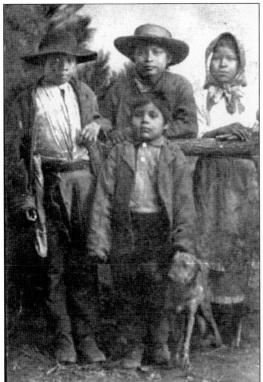

**CHOCTAW CHILDREN AT TALIHINA,
OKLAHOMA.** Pictured here are four
unidentified children with their dog,
taken at Talihina, Oklahoma, in 1909.
The postcard was published by the
Thomas Drug Company. (Courtesy of
Donovin Sprague.)

LUCY KINGSBURY (CHOCTAW).
Lucy Kingsbury was the daughter of J. P. Kingsbury. Her brother was Cyrus H. Kingsbury, and Lucy was a granddaughter of both Rev. Cyrus Kingsbury and Rev. E. Hotchkiss. The latter two were missionaries who emigrated from Mississippi with the Choctaw people. Lucy married a man named Littlepage. (Courtesy of Confederate Memorial Museum and Oklahoma Historical Society.)

ATHENIUS FOLSOM COLBERT AND CZARINA FOLSOM BOND ROBB (CHOCTAW). These were the daughters of Rev. Israel Folsom and Lovica Nail Folsom. Athenius Folsom (left) was born in 1835 and married James Allen Colbert. Czarina was born in 1833 and married Dr. Thomas J. Bond. Following Bond's death, Czarina married David N. Robb. The town of Colbert, Oklahoma, is named for the family of James Allen Colbert. Israel and Lovica Folsom are buried at Boggy Depot. Czarina and her husbands are buried at Westview Cemetery in Atoka. (Courtesy of Confederate Memorial Museum and David C. Steed.)

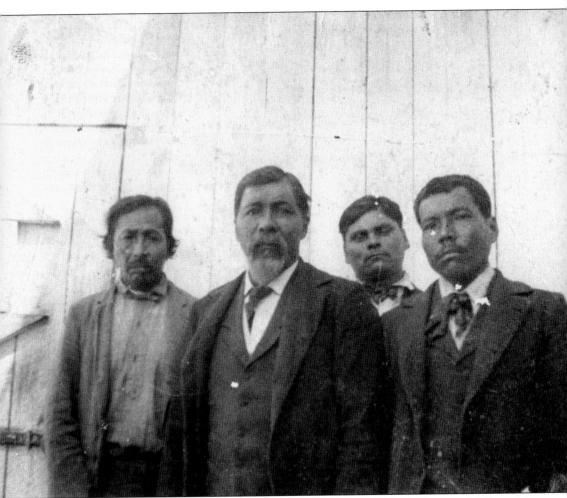

UNIDENTIFIED CHOCTAWS. This photograph was donated to the Indian Territory Museum of Caddo, Oklahoma, and was loaned to the author by the museum. Is this imafo? (Courtesy of Indian Territory Museum.)

ALBERT PIKE COLBERT (CHOCTAW). The son of James Allen Colbert, a Chickasaw, and Athenius M. Folsom Colbert, a Choctaw, Albert Pike Colbert was a grandson of Rev. Israel Folsom. Albert's father, James Colbert, was born in Mississippi in 1832 and moved with his people to the Chickasaw Nation. His marriage to Athenius Folsom brought together two powerful families from each nation. James Colbert died in 1874 at the age of 41. (Courtesy of Confederate Memorial Museum and David C. Steed.)

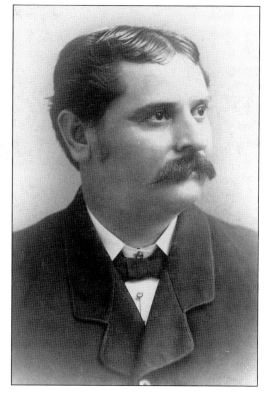

DR. ISRAEL W. FOLSOM (CHOCTAW). Dr. Israel W. Folsom was born in 1846, the son of Rev. Israel W. Folsom and his wife, Lovica Nail Folsom. Dr. Folsom practiced medicine in Atoka in the 1800s. He was involved in a street shooting altercation in Atoka that left Johnnie Harkins dead while Dr. Folsom received a slight flesh wound in the arm. Dr. Folsom died in 1913. (Courtesy of Confederate Memorial Museum and David C. Steed.)

JENNIE TAYLOR BRIGGS WEST AND DAUGHTER GERTRUDE WEST BEENE (CHOCTAW). This photograph is undated. (Courtesy of Randie Ary Graves.)

ANNA "ANNIE" (MOORE) SMALLWOOD (CHOCTAW). This is the only known portrait of Annie Smallwood, from around 1858–1865. Born in 1832, in DeSoto County, Mississippi, she came to Indian Territory on the Trail of Tears, when many died. Her husband, John Smallwood, was born in 1821 in Mississippi and was a member of the Oklafalaya Clan. John died between 1868 and 1874. The (*ya*) Crow (*fala*) People (*okla*) is the meaning. Annie's father was John Moore, a non-Indian. Annie's mother, Betsy, was full-blood Choctaw. (Portrait courtesy of Ralph Dillon Ray family.)

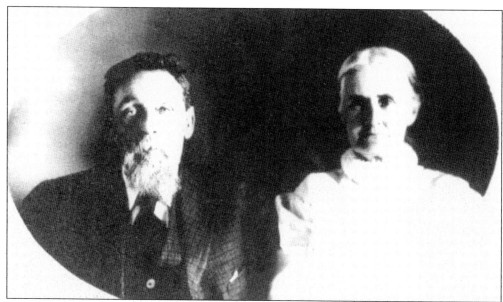

O. P. RAY SR. AND HARRIET RAY (CHOCTAW). O. P. Ray Sr. and Thomas R. Ray are direct descendants of brothers John Smallwood, their great-great-grandfather, and Ben Smallwood, their great-great-great-uncle. They arrived from Mississippi to the Choctaw Nation and began ranching in the Atoka-Lehigh area in 1863. Some of the same land was later allotted in 1903 to Ralph Dillon Ray, the father of O. P. and Thomas. O. P. and Harriet Ray are the great-grandparents of Tinker Ray, who assisted the author. (Courtesy of the Ralph Dillon Ray family.)

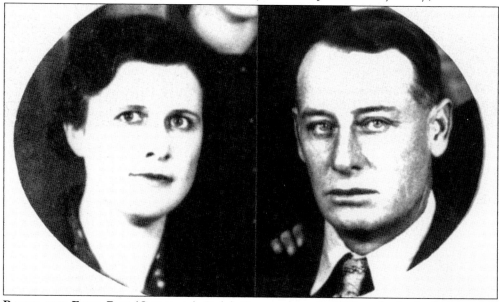

RALPH AND EDNA RAY (CHOCTAW). Ralph Ray was born in 1897 in the back of a wagon in Denver, Colorado. Following the death of his father, William Benton Ray Sr., his mother, Mary, married Charles Ellis. Ellis was an abusive husband and made Ralph and his brother William Benton Ray Jr. live in the barn because of their Choctaw heritage. Ellis was later murdered and robbed while returning from Kansas City by train following a cattle selling trip. (Courtesy of the Ralph Dillon Ray family.)

RAY FAMILY. Pictured from left to right in this 1899 photograph are John Ray, Albert Ray, Tom Paitilo, Oliver Perry Ray Sr., and Bert Ray. This picture was taken on the 77 Bar Ranch owned by O. P. Ray's brother Hezekiah Ray. The ranch was located 12 miles east of present-day Caddo, Oklahoma, in the area of Sugar Loaf Mountain. Albert Ray is the father of Bert Ray. (Courtesy of the Ralph Dillon Ray family.)

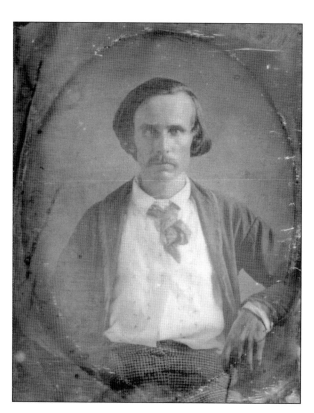

JONITHAN NAIL (CHOCTAW).
This photograph is of Jonithan
Nail. (Courtesy of Confederate
Memorial Museum and Oklahoma
Historical Society.)

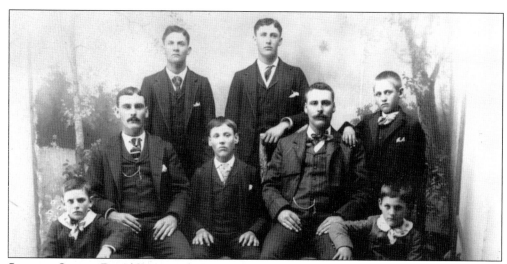

SONS OF OLIVER RAY (CHOCTAW). Pictured from left to right in this c. 1890 photograph are
(first row) Arthur (far left) and Davie (far right); (second row) Oliver Perry II, Dee Moffett,
William Benton Sr., and Dennis Porter; (third row) Albert Walter and John Robert. William
Benton Sr. died in 1898 at the age of 33, Arthur died at about the age of 18, and Davie died
at about the age of 10. William Benton Sr. married Mary Theresa Dillon, and they are the
great-grandparents of David Ray of Tushka, who assisted the author. (Courtesy of the Ralph
Dillon Ray family.)

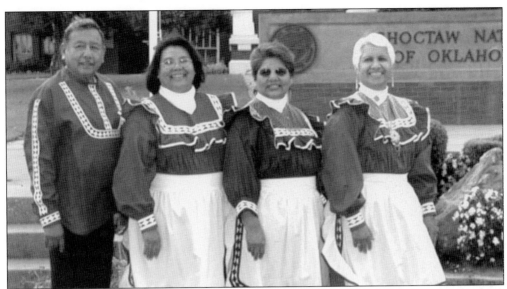

Tribal Office Complex, Durant, Oklahoma. Pictured here in 2005, from left to right, are Richard Adams, Virginia Espinoza, Hannah Bryan, and Lillie Roberts. Richard Adams is from LeFlore and his residence is at Durant. His parents were Leo and Myrtle Adams. Virginia Espinoza is from Boswell, Oklahoma. Hannah Bryan is from Wright City, Oklahoma, and resides in Calera, Oklahoma. Lillie Roberts is from Wilburton, Oklahoma, and resides in Durant. Her parents were McKinley Taylor Sr. and Lizzie Taylor. Everyone in the photograph works for the Choctaw Language Department. Yakoke! (Courtesy of Lillie Roberts.)

Gertrude West Beene (Choctaw). Gertrude West Beene is the daughter of Jennie Taylor Briggs West. (Courtesy of Randie Ary Graves.)

THOMAS DANIEL ARY, MARY REBECCA BRIGGS ARY, AND BABY LUCY ARY (CHOCTAW). Seen here in this 1907 photograph is Thomas and Mary Ary with their baby Lucy. Mary Rebecca Briggs was one-sixteenth Choctaw, and their granddaughter is Randie Ary Graves. (Courtesy of Randie Ary Graves.)

MISS EARL SMISER (CHOCTAW). Miss Earl Smiser represented Indian Territory in a mock wedding ceremony uniting Indian Territory with Oklahoma Territory to form the state of Oklahoma in 1907. Lou Watson represented Oklahoma in this celebration held in Atoka. Harmony and Wards Chapel tied for a prize, with each wagon loaded with 51 people. Miss Smiser was 20 years old during this 1907 celebration and was later known as Mrs. Earl Bryant. A similar pageant was held at Guthrie, the new capital. (Courtesy of Confederate Memorial Museum.)

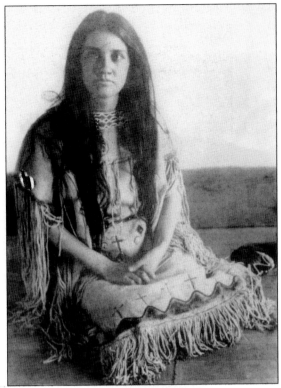

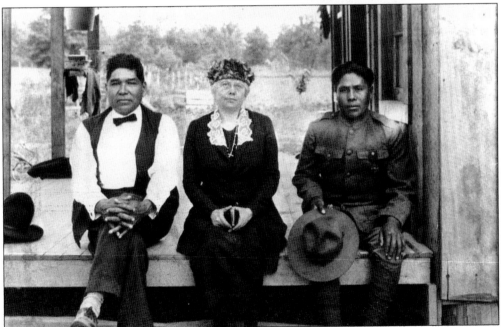

JOHN GOLOMBIE, CZARINA COLBERT CONLAN, AND JOEL JOSEPH OKLAHOMBI (CHOCTAW). The photograph of John Golombie, Czarina Colbert Conlan, and Joel Joseph Oklahombi (from left to right) was taken by W. Hopkins of Idabel, Oklahoma, on May 12, 1921. (Courtesy of Confederate Memorial Museum and Oklahoma Historical Society.)

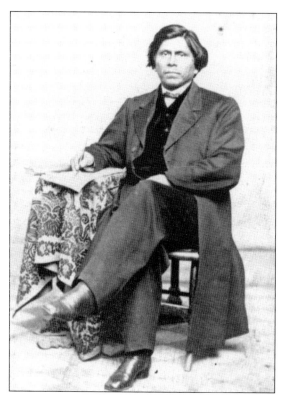

ALLEN WRIGHT (CHOCTAW). Allen Wright came to the Choctaw Nation with his father in the early 1830s. This photograph was taken by a Washington photographer, so it was assumed the picture was taken while Wright was a delegate for the Choctaw there in 1866. Wright was an ordained Presbyterian minister and served as governor of the Choctaw Nation. The photograph was donated by Harriet (Wright) O'Leary. (Courtesy of Confederate Memorial Museum and Oklahoma Historical Society.)

GILES THOMPSON (CHOCTAW). Giles Thompson was a member of the Masonic lodge at Boggy Depot, the first lodge in Indian Territory. He operated a saltworks three miles south of Old Boggy Depot. The notorious Jesse James and his gang from Missouri robbed Thompson of several hundred dollars in gold that was hidden in his house. There were no banks in the country in the early days, and people often left their money with the merchants in town. (Courtesy of Confederate Memorial Museum and Oklahoma Historical Society.)

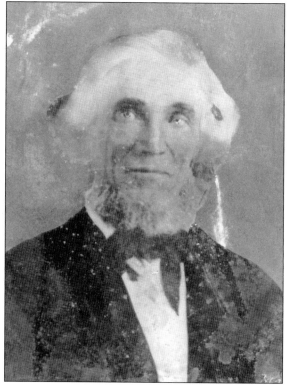

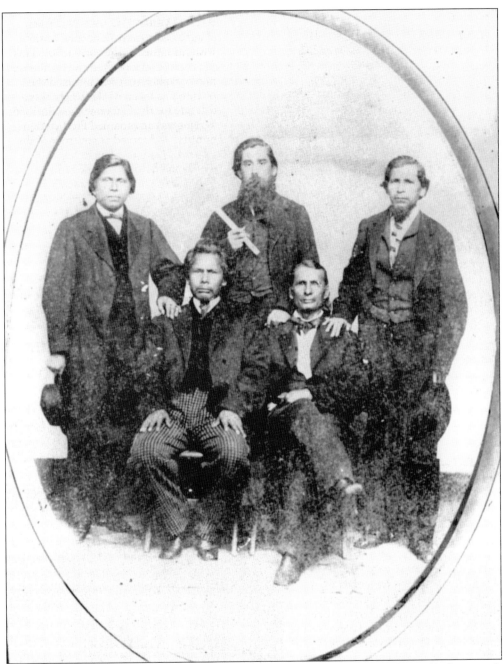

CHOCTAW TREATY DELEGATION OF 1866. Pictured from left to right in this 1866 photograph are (first row) James Utley and Alfred Wade; (second row) Allen Wright, Basil LeFlore, and John Page. This Choctaw delegation traveled to Washington, D.C., to make a new treaty with the U.S. government. It was at this meeting that Wright suggested the name Oklahoma, meaning "red people," for the state name. At this time he was also elected principal chief/governor of the Choctaw Nation. (Courtesy of Confederate Memorial Museum and Oklahoma Historical Society.)

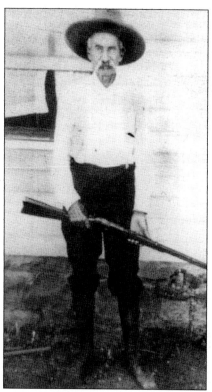

LYMAN PUSLEY (CHOCTAW). Lyman Pusley was deputy sheriff at Wilburton during the last execution of a Choctaw under tribal law. Executed was Silas Lewis, a former sheriff; he requested that Pusley perform the duty. The execution took place south of Wilburton in 1894. Pusley had to keep Silas Lewis at the Pusley home, handcuffed to a bed, prior to the execution. Finally Pusley turned him loose and told Silas to return on the execution day, and Silas kept this promise. Pusley and his wife, Lizzie, had four daughters, and he lived to the age of 93 and was buried at Gerty. (Courtesy of Choctaw Nation of Oklahoma.)

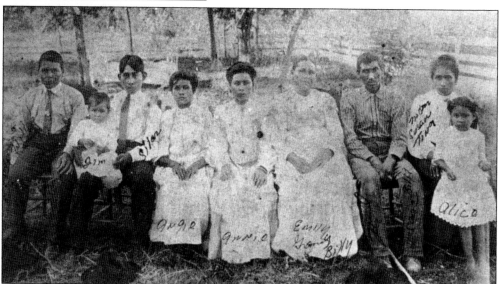

THE BILLY FAMILY. Pictured here in this c. 1907 photograph, from left to right, are William Billy, James Billy, Silas Byington, Anganora "Angie" Billy, Annie Billy, Emily Billy, Isaac Billy, Susan Billy Byington, and Alice Billy (Choctaw). This is the family of Isaac and Emily Billy from Daisy, Oklahoma. Will Billy married Sophia Morris. James married Berniece Mead. Silas Byington married Susan, and she later married A. G. Brummitt. Anganora married Will Page and later Charles Isom. Annie married into the Burleson, Newkirk, and then Bond families. Alice married Clyde Bacon. (Courtesy of Tom Williams.)

ALINTON RUSSELL TELLE. Alinton Telle was born in Atoka in 1893 to Alinton Telle Sr. and Emma Russell Telle. He spent his life in Atoka, never married, and served many years as district court reporter. The photograph was taken around 1898, and Alinton lived until 1958. His father, Alinton Sr., was born in Boktuklo County in 1859, the son of Ima-no-bubbi. Ima-no-bubbi married Kate Wright, a sister of Gov. Allen Wright of the Hayip-tukla clan of the Choctaw. (Courtesy of Confederate Memorial Museum and David C. Steed.)

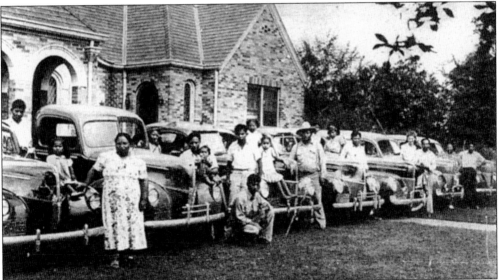

SILSAINEY (JONES) WARD AND FAMILY (CHOCTAW). Silsainey (Jones) Ward was known for her philanthropies and oil wealth. She lived in Smithville in the 1930s in the Quachita Mountains. In the photograph she is third from left. Faye Tekubie Roman is the child sitting on the car next to her. Wanonda Marie Tekubie is the baby held by Leroy Samuels. Leo Johnson is next to him followed by Bertha Mae Ward Tonika, Reed Ward (her husband), Edith Johnson, Joe Johnson, Ruth and Jessie Watson, Lodie Going, and Perry Jones. (Courtesy of Wesley Samuels and Choctaw Nation of Oklahoma.)

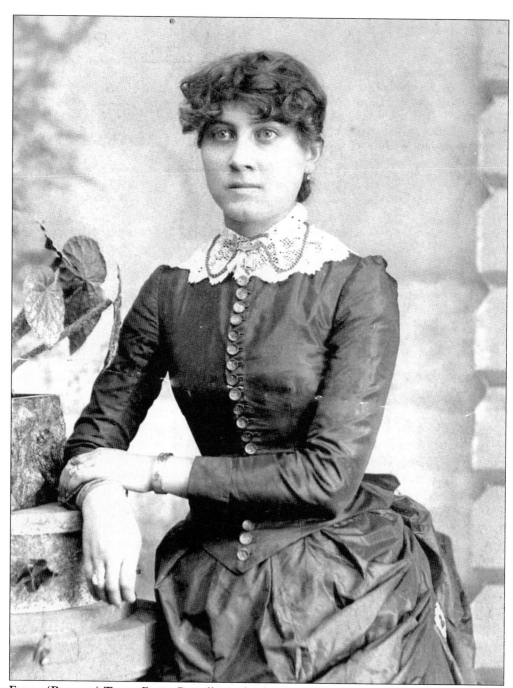

EMMA (RUSSELL) TELLE. Emma Russell was the daughter of William Wesley Russell and Louisa Cooper. Her first husband was W. J. Leary, and he died in 1886. In 1890, she married Atoka attorney Alinton Telle Sr., and they had two children, Nanima Louise who died at age two, and Alinton Russell. Emma was active in the Methodist church and the Pioneer Club, was held in high esteem, and was described as a most charming lady. (Courtesy of Confederate Memorial Museum and David C. Steed.)

WALTER CHURCHILL HARRIS. Walter Churchill Harris was born in 1870 to Henry C. Harris and Margaret "Maggie" Lee. He lived in McCurtain County all of his life, as a farmer/rancher, postmaster, and general store operator. He married Sally Washington, a full-blood Choctaw whose parents were Sid-Ken and Mary Washington. Walter and Sally had five children, and Walter later had two more marriages, to Sarah Elizabeth Warren and Effie O. Harris. Walter liked to fish and play the fiddle. Walter died in 1937 at Pleasant Hill. (Courtesy of Tommy V. Whiteman.)

UNIDENTIFIED GRANDFATHER (CHOCTAW). This is an unidentified grandfather of Viola "V" May Jones Harrell. He is pictured here with a buggy and team of horses. (Courtesy of Berl and V. Harrell.)

UNIDENTIFIED AUNT AND CHILD (CHOCTAW). This is an unidentified aunt of Viola "V" Jones Harrell. No other information is known at this time about this photograph. (Courtesy of Berl and V. Jones Harrell.)

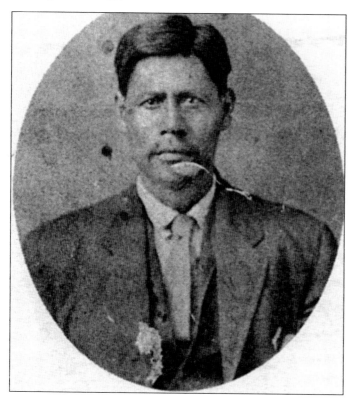

LEE J. ALLISON (CHOCTAW). Lee Allison was born in 1865 and was in the Choctaw council in this 1906 photograph. East Allison, near Bentley, was named for him. This land was later owned by Bob Rains. Allison died in 1916, and a huge tombstone marks his lone grave. His widow was Emma Webster. His brother Calvan Allison settled west of Bentley, and West Allison was named for him. A ferryboat operated on Clear Boggy River. Choctaw families here were Anderson, Barcus, Billy, Carnes, Cole, Fisher, Jack, LeFlore, and Woods. (Courtesy of Atoka County Historical Society.)

TOM WILLIAMS (CHOCTAW). This 1944 photograph was taken in Pawhuska, Oklahoma, at the Osage Nation. Tom Williams is now the director of real property management with the Choctaw Nation of Oklahoma. He is a friend of the author, and this picture may be from his rodeo days. His parents were Bert Williams and Myrtle Emily Byington. (Courtesy of Tom Williams.)

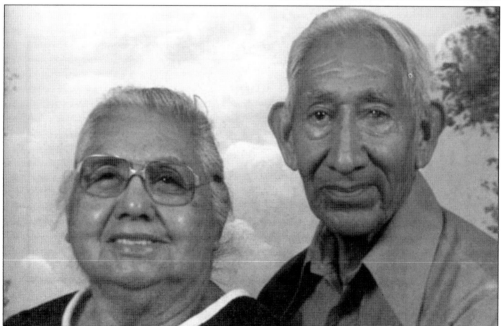

MCKINLEY TAYLOR SR. AND WIFE LIZZIE PARISH TAYLOR (CHOCTAW). McKinley Taylor Sr. and Lizzie Taylor are the parents of eight children. McKinley was born in Damon, Indian Territory, and Lizzie Parish was born in Darwin, Indian Territory. They are both original Choctaw enrollees. (Courtesy of Lillie Roberts.)

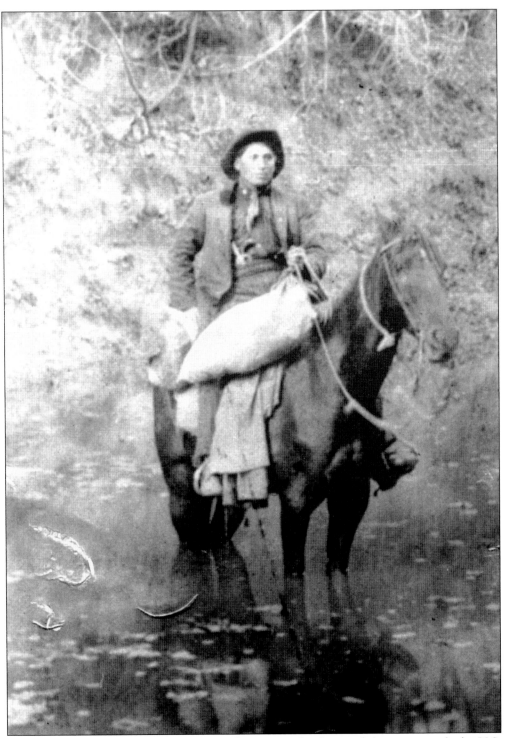

ISAAC BILLY (CHOCTAW). This is Isaac Billy watering his horse while serving with the U.S. Postal Service. This *c.* 1908 photograph was taken in McGee Creek, Redden, Oklahoma. (Courtesy of Tom Williams.)

ELMA MAE (WALL) PANTER AND CLARENCE WALL. (CHOCTAW).
Brother and sister Clarence Wall and Elma Mae Wall were born in the early 1900s in the Kiamichi Valley. Elma Mae was the mother of Melvin Thomas Panter of Sulphur Springs, Texas, who provided the photograph. Melvin stated that his mother and uncle pictured here were blood siblings. Clarence was registered with the tribe as one-half Choctaw, and Elma Mae was registered as less than half Choctaw by error. Melvin Panter and his wife, Merle (Tolbert) Panter, have three children: Gary Brad Panter; Linda Gail (Panter) Ross; and Mark Thomas Panter. (Courtesy of Melvin Thomas Panter.)

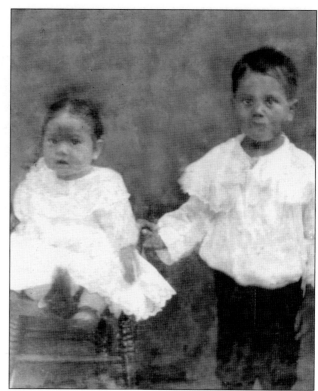

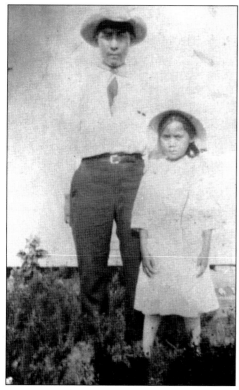

SILAS HOLSON BYINGTON AND MYRTLE EMILY BYINGTON (CHOCTAW). Silas Holson Byington is pictured in this c. 1916 photograph with his daughter Myrtle Emily Byington, who later became Myrtle Williams. (Courtesy of Tom Williams.)

JENNIE BRIGGS (CHOCTAW).
Jennie Briggs was thought to have married seven times; her last names included Briggs, West, Ivie, Barnes, Covington, and Loftlin. Lastly she married Berry C. Smith. Jennie and Berry are buried together at the Stigler, Oklahoma, cemetery. (Courtesy of Randie Ary Graves.)

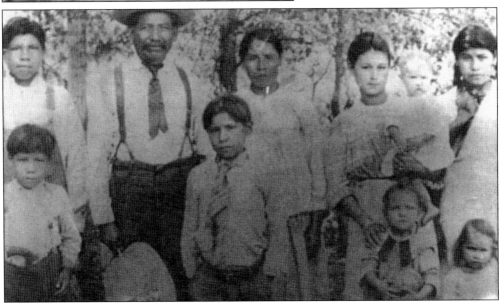

THE PAXTON FAMILY (CHOCTAW). Pictured in 1913 are (first row) Rufus Paxton (far left) and Swinney G. Paxton (second from left); (second row) Norris Paxton (far left), Gabrial Paxton (second from left), Susan Wells Paxton (third from left), Melvina Jones Cantrell (fourth from left), and Selina Paxton (top right). Melvina Cantrell's children are Bill Cantrell, Stella Boatright, and Ella Kennedy. The parents of Gabrial Paxton were Achafantubby and Molsy. He married Susan Wells Push, and their children were Norris, Selina, Rufus, and Swinney. Gabrial and Susan both died in 1913, and their children were orphaned. Children from Susan's first marriage were Melvina and Alfred Wells. (Courtesy of Choctaw Nation of Oklahoma and Oklahoma Historical Society.)

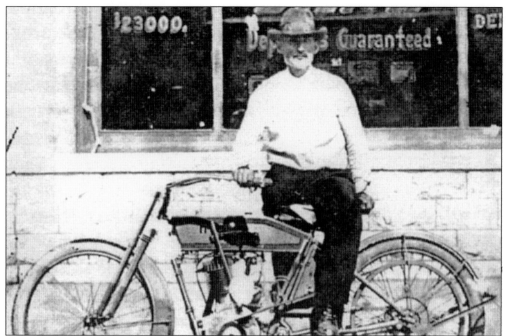

JOSEPH (JOE) R. HALL WARD (CHOCTAW). This *c.* 1919 photograph was taken in downtown Spiro, Oklahoma. The building was later occupied by Spiro Graphic. Joseph (Joe) R. Hall Ward is proudly displaying his Harley Davidson motorcycle. (Courtesy of Wesley Samuels and Choctaw Nation of Oklahoma.)

MARION ALVIN BRIGGS (CHOCTAW). Marion Alvin Briggs is on the Choctaw Rolls and is the son of Jennie Taylor Briggs. (Courtesy of Randie Ary Graves.)

MARY REBECCA BRIGGS ARY (CHOCTAW). Mary Rebecca Briggs Ary is the grandmother of Randie Graves of Broken Arrow, Oklahoma. (Courtesy of Randie Ary Graves.)

IRENE HUDSON HEARD (CHOCTAW). Irene Hudson Heard was a student at Haskell when this photograph was taken. She was born in 1897 and was from Haileyville. Harry J. W. Belvin, chief of the Choctaw Nation, commissioned her as "Goodwill Ambassador for the Choctaw Nation" in 1973. She was also known as "Belle of the Kiamichi Mountains," and her daughters are Suzanne Heard and Betty Jane Heard Watson. A dormitory at Jones Academy is also named for her. (Courtesy of Suzanne Heard, Betty Jane Heard Watson, and Choctaw Nation of Oklahoma.)

Four

CHAHTA NAN IꞭHVNA HOLISSO APISA

(CHOCTAW EDUCATION AND SCHOOLS)

JONES ACADEMY NEAR HARTSHORNE. Jones Academy is located four miles northeast of Hartshorne. Many non-Indian missionaries began their work among the Choctaws, some prior to the removal from Mississippi. In 1872, a call was issued to churches of the Choctaw and Chickasaw Nations to meet for the purpose of organizing for education and schooling. Elliot Academy was another 19th-century boarding school in Smithville. (Courtesy of Jones Academy Museum, early 1960s.)

ARMSTRONG ACADEMY "CHAHTA TAMAHA." Armstrong Academy is shown in this 1910 photograph. It was located east of Caddo and north of Bokchito. It was established by the Choctaw Nation and named for William Armstrong, Indian agent. Banty, near Ten Mile Hill, was just east of the academy. It opened in 1843 (a marker says 1845). During the Civil War it was the Confederate capitol and later renamed Chahta Tamaha (Choctaw City). Choctaw chiefs here included Peter Pitchlynn, Allen Wright, and Jackson McCurtain. This site is vacant today, and the capitol moved to Tuska Homma. (Courtesy of Choctaw Nation of Oklahoma and Oklahoma Historical Society.)

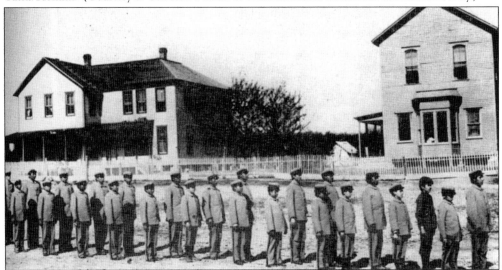

ATOKA BAPTIST ACADEMY. Early newspaper accounts of October 31, 1885, call Prof. B. S. Smiser's school the Atoka Baptist Academy. It appears the former name was Rehoboth Mission School, and the latter was also the name of the very first school in Atoka, Indian Territory. About 1878, Prof. O. C. Hall was principal. Rev. J. S. Murrow and his second wife, Clara Burns Murrow, arrived in 1867, and she was the first teacher at the school. (Courtesy of Oklahoma Historical Society, 1892.)

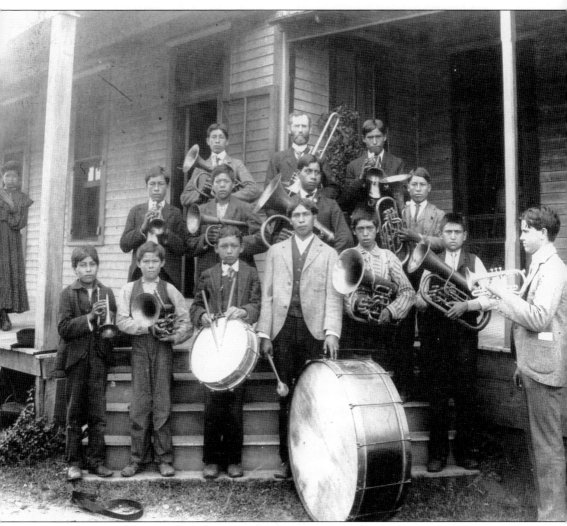

MURROW INDIAN ORPHAN'S HOME BAND. Father Murrow provided a home for Choctaw and American Indian orphans. By 1902 the Indian Orphanage purchased the building and land. It operated in Atoka that year and then moved to a farm 15 miles north of town. It was called Unchuka, but by 1910 the home moved to the grounds of Bacone College, near Muskogee. Another school, the Presbyterian Mission School, was built in 1887. This photograph is from 1896. (Courtesy of Confederate Memorial Museum and Oklahoma Historical Society.)

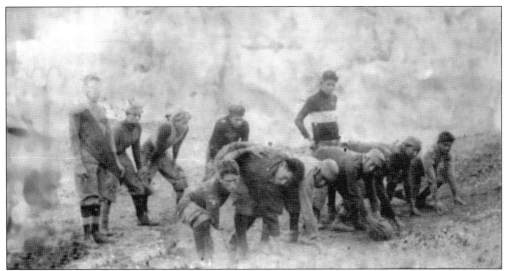

JONES ACADEMY FOOTBALL TEAM, 1905–1906. This 11-man football team is ready for action. In 1952, the school became a residential care center for American Indian students. Today there are about 236 students at Jones Academy who attend Hartshorne School. Jones Academy has been in continuous existence since it opened. (Courtesy of Jones Academy Museum.)

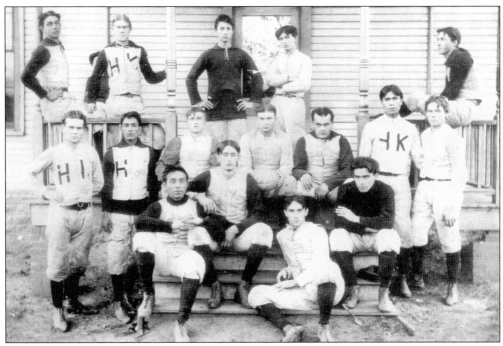

CHOCTAW FOOTBALL TEAM. This photograph is comprised mainly of Choctaw football players. As schools developed, missionaries such as Cyrus Byington developed a lexicon of the Choctaw language to translate Christian prayers, hymns, and Bible passages into Choctaw. The language was oral, not written. After nearly 50 years he compiled A *Dictionary of the Choctaw Language*, edited by John Swanton and submitted to the Bureau of Ethnology in 1909. (Courtesy of Donovin Sprague.)

REV. J. S. MURROW. Reverend Murrow was a missionary to the Choctaw Indians and established Atoka's First Baptist Church in 1869. He worked with Rev. R. J. Hogue during the Civil War years in the Choctaw Nation. Reverend Murrow began reorganizing churches that had been destroyed and disbanded during the war. His second wife, Clara Burns Murrow, started the first school in Atoka, Indian Territory, in March 1867. It was called Rehoboth Mission School. (Courtesy of Confederate Memorial Museum and Oklahoma Historical Society.)

REV. CYRUS BYINGTON. Rev. Byington arrived in 1836 and organized a church called Lappita Bok Aiittanaha, or Buck Creek Church. East and southeast of this church was Six Town Settlement. Another area south of Eagletown was Apehkah Settlement. Rev. Byington was called by the Choctaws Lapish (horn) Olahanchi (keeping/blowing horn) because he sounded a cowbell when church started. He would have three or four churches, including Stockbridge Missionary School, a name given because Rev. Byington was born in Stockbridge, Massachusetts. (Courtesy of Confederate Memorial Museum.)

JAMES "MICKEY" MCCLURE (CHOCTAW). James "Mickey" McClure was a student at Jones Academy. The author found birth records of several generations of people by the name of James McClure, most of them from McCurtain County, Oklahoma. (Courtesy of Jones Academy Museum.)

DOLLIE CLAY, SHIRLEY PAGE, AND OLA MANION (CHOCTAW). These girls are at Tuska Homma with their toli sticks in this c. 1957 photograph. Dollie Clay (left) is the daughter of Henry Clay, Shirley Page (center) is the daughter of Bob Page, and Ola Manion is the daughter of Bess Manion. (Courtesy of Tom Williams.)

JOY WHITE. Joy White's father was a carpenter at Jones Academy near Hartshorne, Oklahoma, and Joy is "waving at Bushy" in this photograph. Jones Academy was established in 1894. In 1955, Wheelock, a girls boarding school, closed and 55 girls transferred into Jones Academy. (Courtesy of Jones Academy Museum.)

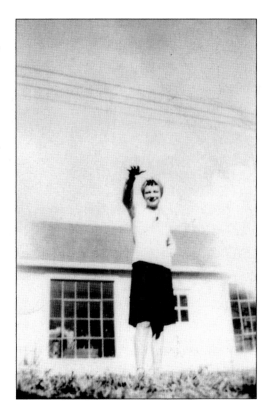

GYMNASIUM AT JONES ACADEMY. Inez Sitter of Jones Academy remembered this gymnasium being used for Saturday night shows, boxing, dancing, and basketball. The school was once under the control of the Bureau of Indian Affairs but is now owned and operated by the Choctaw Nation of Oklahoma. Since students attended this school from throughout the Choctaw Nation, photographs represent a good mixture from various counties. (Courtesy of Jones Academy Museum.)

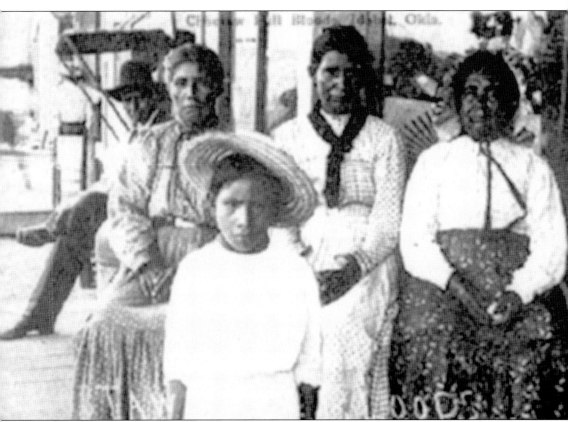

CHOCTAW GROUP IN IDABEL. This Choctaw group is pictured in downtown Idabel. The Museum of the Red River in Idabel is a resource stop for study of the Choctaw and Caddo people. Nearby Fort Towson was first known as Camp Phoenix and served as a Confederate command post during the Civil War. It is Oklahoma's second-oldest military outpost, established in 1824. In 1847, the Fort Towson Post Office name was changed to Doaksville, once the capital of the Choctaw Nation. Chief George Hudson, David Folsom, and Robert M. Jones were early noted Choctaws here. (Courtesy of Donovin Sprague.)

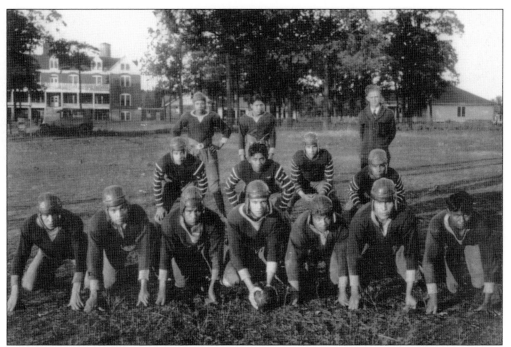

JONES ACADEMY FOOTBALL TEAM. The players are unidentified in this 1932 photograph. Jones Academy was named for Wilson N. Jones, principal chief of the Choctaw Nation from 1890 to 1894. (Courtesy of Jones Academy Museum.)

AGNES JOY SPURLOCK, JAMES MEARS, AND ADDIE GUNTER. Seen in this 1955 photograph, Agnes Spurlock (left) was superintendent of Jones Academy from 1955 to 1964, and a boys' dormitory is named for her today. James Mears (center) and Addie Gunter were social workers from the Bureau of Indian Affairs in Muskogee, Oklahoma. The first superintendent at the school was Simon T. Dwight from 1891 to 1894, followed by Jane McCurtain and W. A. Durant. (Courtesy of Jones Academy Museum.)

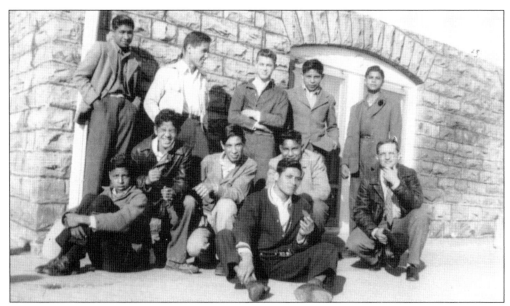

JONES ACADEMY STUDENTS. Pictured from left to right are (first row) Nathan Benton, Archie Peters, Jerry Underhill, Benjamin Carnes, Mickie McClure, and Robert H. Wood (coach); (second row) Solomon Henry, Steve Barnett, Wallace Jefferson, Sam Lewis, and Burnett James. (Courtesy of Jones Academy Museum.)

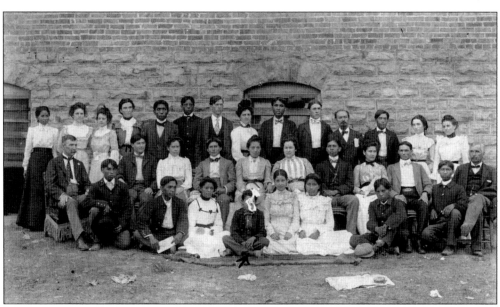

JONES ACADEMY STAFF AND STUDENTS. The only identified student is Willie Nelson Dunegan. Willie Dunegan was born in 1889 and lived until 1959. Alabama Fuller is pictured in the back row, far right. (Courtesy of Jones Academy.)

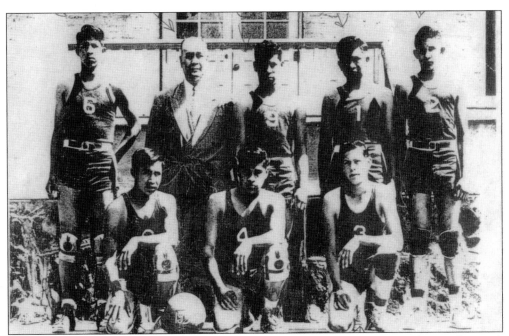

BASKETBALL TEAM AT JONES ACADEMY (CHOCTAW). Pictured from left to right are (first row) Nelson Noahubbe, Loyd Parmacher, and Edward Imotiskey; (second row) Joshua Pickens, Emment McLemore, James Hudson, Preston LeFlore, and Dan Cass. (Courtesy of Jones Academy Museum.)

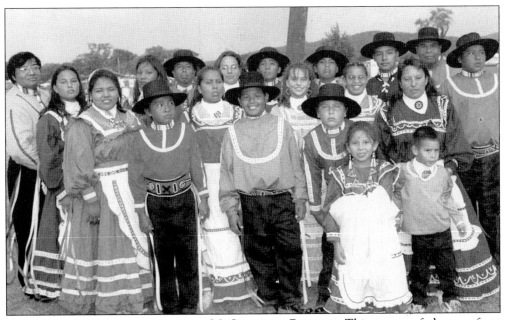

CHOCTAW YOUTH DANCERS FROM McCURTAIN COUNTY. This group of dancers from McCurtain County is participating in traditional Choctaw dancing in this 2000 photograph. (Courtesy of Choctaw Nation of Oklahoma.)

CHOCTAW STUDENTS. These students are not identified, but it is assumed they are from Jones Academy. Another institution, Wheelock Mission, was founded in the 1830s as a mission station, church, and school. It is Oklahoma's oldest church, completed in 1847, and is located east of Millerton. A written Choctaw language would also evolve. (Courtesy of Jones Academy Museum.)

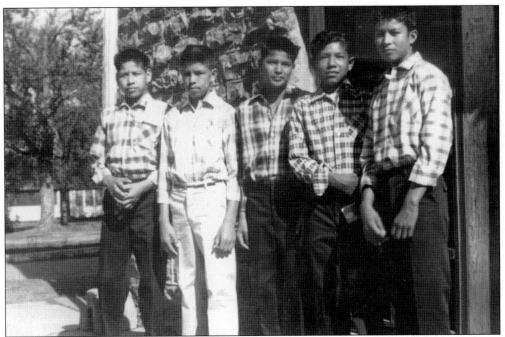

CHOCTAW STUDENTS AT JONES ACADEMY. Pictured from left to right are Johnny Webber, Johnny Anderson, Frank Mitchell, Kyle Billy, and Curtis Watson. (Courtesy of Jones Academy Museum.)

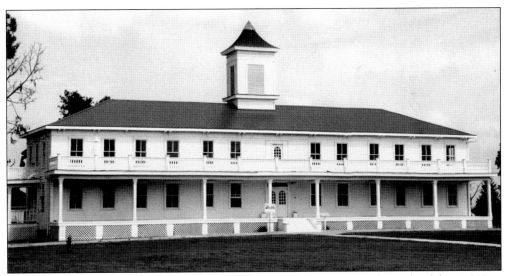

WHEELOCK ACADEMY. The Wheelock Academy served as a girls' boarding school from 1833 to 1955. It was 10 to 12 miles north and west of Idabel, known as Towson County, Choctaw Nation, Indian Territory, before statehood. This is now McCurtain County. Wheelock was named after Eleazar Wheelock, founder of Moor's Indian School, later known as Dartmouth College. Pushmataha Hall was built in 1884 and still houses the original bell in the tower. (Courtesy of Choctaw Nation of Oklahoma.)

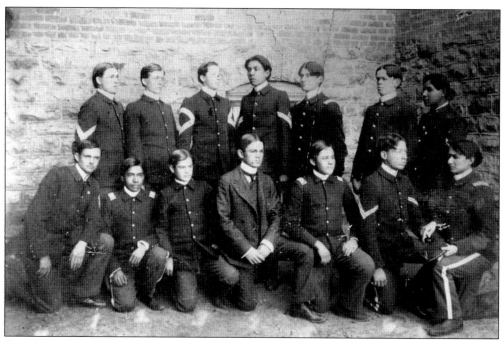

CHOCTAW STUDENTS IN UNIFORM. The students are unidentified. (Courtesy of Jones Academy Museum.)

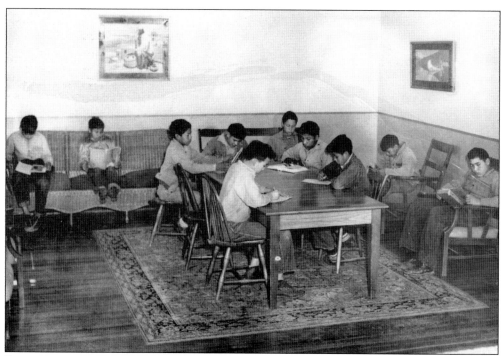

STUDENTS AT JONES ACADEMY. These students are busy reading and writing their assignments at Jones Academy in this 1951 photograph. (Courtesy of Jones Academy Museum.)

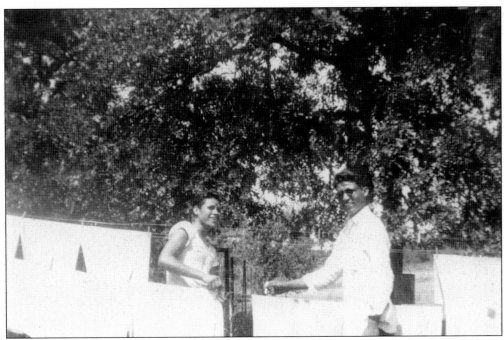

JAMES MCCLURE (LEFT) AND RUSSELL BILL (CHOCTAW). This picture was taken while these students were attending Jones Academy. (Courtesy of Jones Academy Museum.)

LYDIA PIEPGRASS (CHOCTAW). Lydia Piepgrass is listed as assistant matron at the Atoka Baptist Academy in 1893–1894. Other staff listed in the catalog are trustees Mrs. C. Robb, president; Rev. J. S. Murrow; H. Y. McBride; Mrs. W. A. McBride; Rev. C. A. Freeman; Mrs. M. C. Reynolds (Cambridge, Massachusetts); and Edwin H. Rishel, secretary. The faculty included Edwin H. Rishel (principal), Magdalene Baker (assistant principal), Myra A. Shaw (Intermediate Department), and Ella M. Rishel (matron). (Courtesy of Confederate Memorial Museum.)

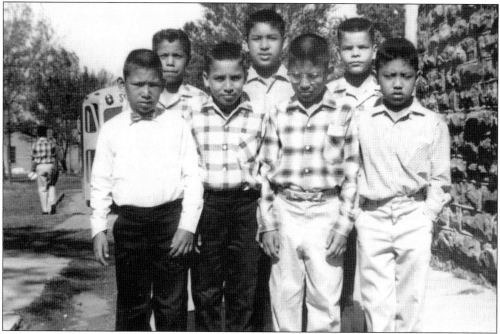

JONES ACADEMY STUDENTS DAN PERRY AND JACK KING. Dan Perry is at the far left, first row, and Jack King is at the far right in the back row. The other students are unidentified. (Courtesy of Jones Academy Museum.)

HOSPITAL AT JONES ACADEMY. The hospital at Jones Academy had a full-time nurse for the children and a contracted doctor. This building is still in use for social services today and is located near the museum. (Courtesy of Jones Academy Museum.)

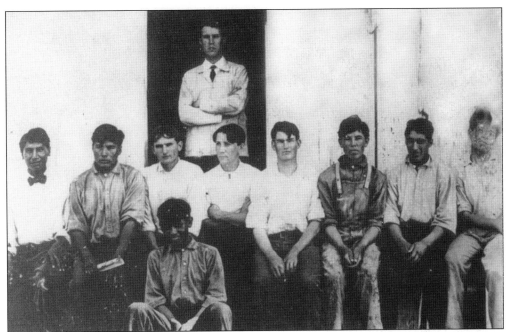

STUDENTS AT JONES ACADEMY. Pictured from left to right in this 1908–1909 photograph are George Hocklotubbe, Joseph Caesar Davis, Warren Ward, John B. James, Dwight Bell, Jack Dwyer, Charles A. Buck, and James Jones. The man in back (possibly the teacher) and student in front are not identified. (Courtesy of Jones Academy.)

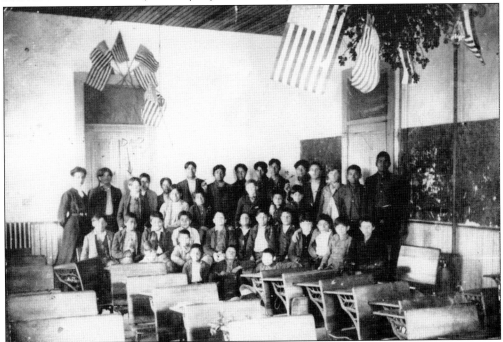

JONES ACADEMY CLASSROOM. This 1900 classroom photograph of students and a teacher consists of 37 people. Jessie "Sal" Elmer Ward is standing in the back row, third from the left. (Courtesy of Jones Academy Museum.)

JONES ACADEMY GRADUATING CLASS OF 1903 (CHOCTAW). Pictured from left to right are (first row) Joshua W. Anderson, Alexander L. McIntosh, Edwin G. Goodnight, and Charles Plato; (second row) Perry M. Willis, Clarence Willis, and Walter F. Leard. (Courtesy of Jones Academy Museum.)

JONES ACADEMY BASKETBALL TEAM. Pictured from left to right in this 1956–1957 team photograph are (first row) Tommy Loudermilk, Virgil Sanders, and Joe Mose; (second row) Wallace McGirt, Kenneth Meely, Wayne Scott, Barney Billie, and James Wilson. (Courtesy of Jones Academy Museum.)

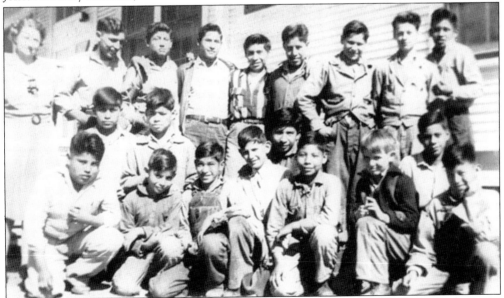

JONES ACADEMY, FIFTH GRADE. Pictured from left to right are (first row) Franklin Frances, unidentified, unidentified, Harley Jones, Joe July, Charles Lee, and Joe Swinney; (second row) Roy ?, unidentified, Theodore LeFlore, and Leroy "Stove Pipe" Daily; (third row) Mrs. Robert Wright, Joe Red Eagle, unidentified, James McClure, James Carney, unidentified, Clemo Jefferson, Kenneth Dennison, and Nelson Parker. This 1945 photograph is from the H. Wood Collection. (Courtesy of Jones Academy Museum.)

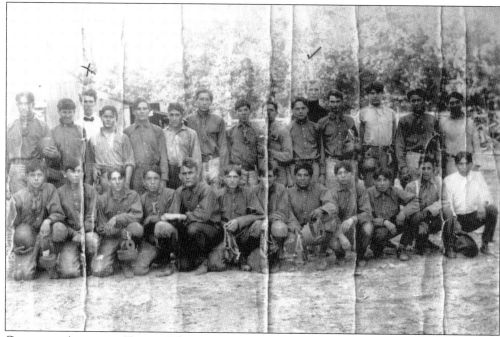

CHOCTAW ATHLETIC TEAMS. This is a 1908–1909 photograph of Choctaw ballplayers with two staff in the back row in the white shirt and in the black shirt. The coach is Arthur Ashley. (Courtesy of Jones Academy Museum.)

JOSHUA CLYDE PICKENS (CHOCTAW/ CHICKASAW). Joshua Pickens was born in 1933 and is now 73 years old. He grew up at Blanco and Plainview, Oklahoma. In 1943, he started the second grade at Jones Academy. In 1951, he completed the seventh grade. There were nine brothers and sisters in the family, and most of them died of tuberculosis before Joshua was born. They were buried at Brushy Indian Church near Blanco. Joshua had two sisters. He now lives at High Hill near McAlester, Oklahoma. (Courtesy of Patti Scott.)

Five

CHAHTA HIHLA MICHA KANIOHMI HOSH ASHA

(CHOCTAW DANCE AND CULTURE)

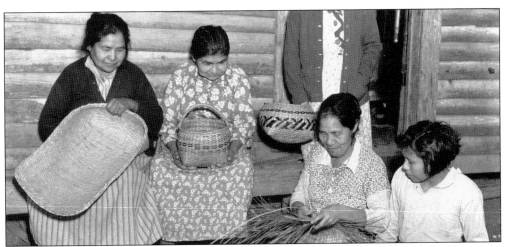

CHOCTAW BASKET MAKERS. These ladies are making baskets at St. Matthews Church in McCurtain County, on December 14, 1937. Choctaw *tapushik* (baskets) have different variations, which have been handed down. The Choctaw Nation welcomes all people to the powwow held each year during the Labor Day Festival at Tuska Homma in Pushmataha County. Basket weaving is one of the many traditional cultural demonstrations at the festival. (Photograph by Andrew T. Kelley; courtesy of Jones Academy Museum.)

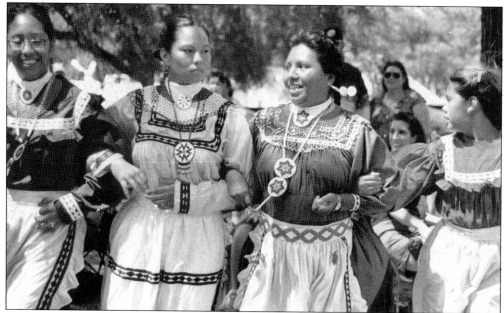

MCKINNEY DANCERS AT TUSKA HOMMA. The McKinney Dancers are demonstrating Choctaw social dancing on the capitol grounds at Tuska Homma, Oklahoma, during the Labor Day Festival in 2004. The raccoon dance, friendship dance, jump dance, snake dance, and stealing partner dance are performed. (Courtesy of Choctaw Nation of Oklahoma.)

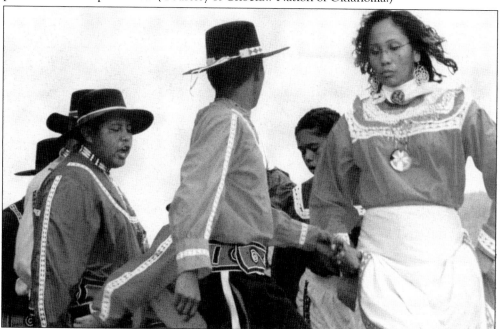

CHOCTAW DANCERS. These Choctaw dancers are demonstrating a four-step war dance in this 2005 photograph. War dances started eight days before a battle, and men and women participated in the dance. Women were honored as the "givers of life." Men drew from the strength of the women in battle. Women could hand arrows to the men on the battlefield. (Courtesy of Choctaw Nation of Oklahoma.)

BETTY KETCHESHAWNO (CHOCTAW). Betty Ketcheshawno is pictured here with her ash spoon ready to taste some *tanchi labona*. The recipe is to cook hominy corn for three hours in a large pot of water. Add either one pork backbone, a neck bone, or rib meat to the corn and let cook until the meat is tender. Salt to taste. The corn will rise, so only two cups of corn are needed to make a meal. After the corn starts boiling, cut the heat down low and let it cook, but stir occasionally to keep from sticking. (Photograph and recipe courtesy of Choctaw Nation of Oklahoma, around 2005.)

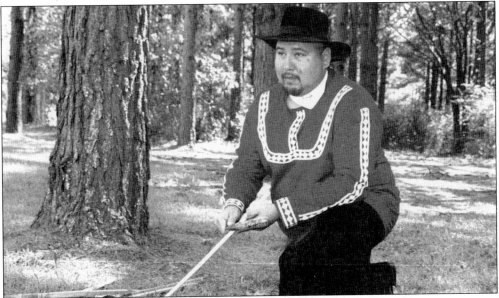

BYRON BILLY (CHOCTAW). In 2005, Byron Billy is seen demonstrating the shaping of a piece of hickory into a *kapucha* (stickball stick). This ball game could involve hundreds of players and even larger audiences. Players attempt to get a woven leather ball downfield and touch it to the opponents' goalpost. Only the sticks can be used in passing the ball. "The little brother of war," stickball was often played to resolve disputes within the tribe. The game has been played since before the Civil War. (Courtesy of Choctaw Nation of Oklahoma.)

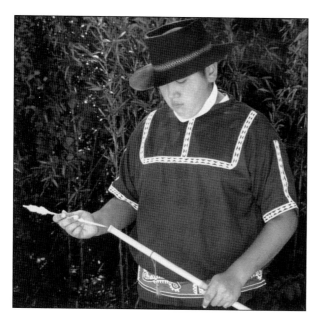

MAHLI BILLY (CHOCTAW). Mahli Billy is seen in 2005 loading a wooden dart into his *uski hlumpa* (blow gun). The uski hlumpa was made of hollow cane 6 to 12 feet long and was often used by boys in hunting small game. Hot coals are dropped through the middle of the cane to clean it out. Wooden darts were made of thistledown, but cotton was used later. (Courtesy of Choctaw Nation of Oklahoma.)

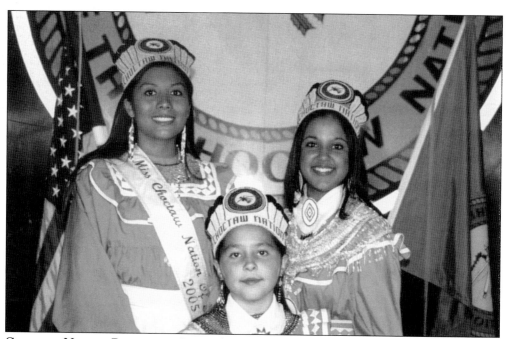

CHOCTAW NATION PRINCESSES. Pictured from left to right in 2005 are Miss Erica McMillan, Little Miss MacKenzie Maxwell, and Junior Miss Jenny Townsend. The new Choctaw Nation Princesses for 2006–2007 are Senior Miss Courtney Baker, Junior Miss Ashton Dinardo, and Little Miss Emily Rowell. (Courtesy of Choctaw Nation of Oklahoma.)

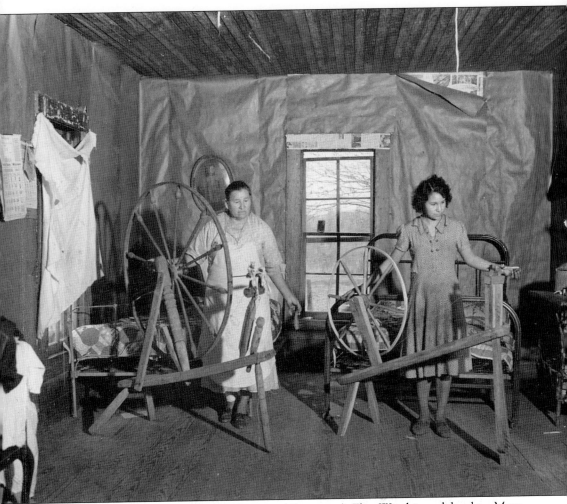

ELIZA WINSHIP AND DAUGHTER MARY WINSHIP (CHOCTAW). Eliza Winship and daughter Mary are working in their home with two wool spinning wheels in this December 13, 1937, photograph. Eliza was born on October 10, 1886, and died on June 15, 1966, at Broken Bow, Oklahoma, in McCurtain County. (Photograph by Andrew T. Kelley; courtesy of Jones Academy Museum.)

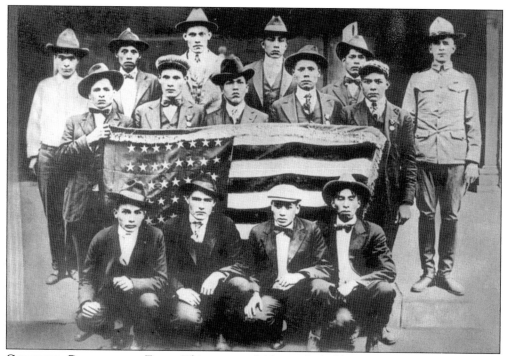

CHOCTAW GROUP WITH FLAG. This group of 15 people holding the United States flag is unidentified. (Courtesy of Jones Academy Museum.)

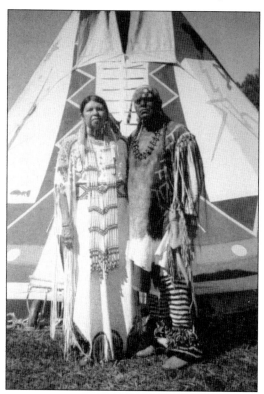

VIOLA "V" AND BERL HARRELL (CHOCTAW). Viola "V" and Berl Harrell are traditional dancers who have 4 children and 12 grandchildren. Berl is of Oklahoma Choctaw descent, and his regalia is a combination of Choctaw and Lakota peoples. His shirt is in honor of the vision quests. The "coup" marks on his leggings represent how many dances he has attended as a lifetime member of Indian Intertribal Association of Arkansas. They live in Damascus, Arkansas. (Courtesy of Berl and V Harrell.)

MICHAEL ROBERTS (CHOCTAW). Michael Roberts is dressed in his traditional regalia in this photograph. (Courtesy of Choctaw Nation of Oklahoma.)

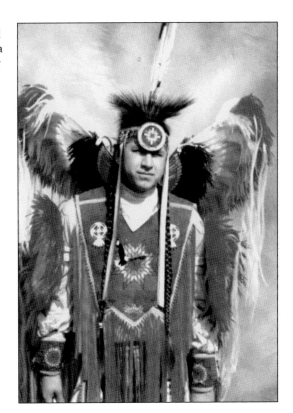

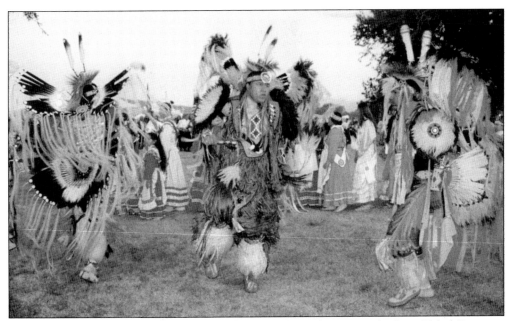

TUSKA HOMMA GRAND ENTRY. This is the annual grand entry at the Inter-Tribal Powwow, held on the first day of the Choctaw Nation Labor Day Festival at Tuska Homma. (Courtesy of Choctaw Nation of Oklahoma.)

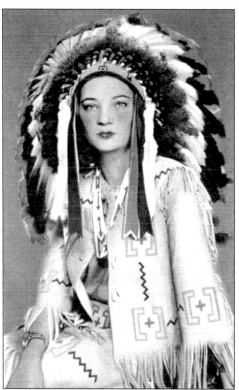

CHOCTAW WOMAN. This is a postcard with a Choctaw woman in Plains Indian–style regalia. It was entitled "Choctaw Indian Princess, Oklahoma" and was courtesy of the Oklahoma City Chamber of Commerce, possibly from the 1940s or 1950s. (Courtesy of Donovin Sprague.)

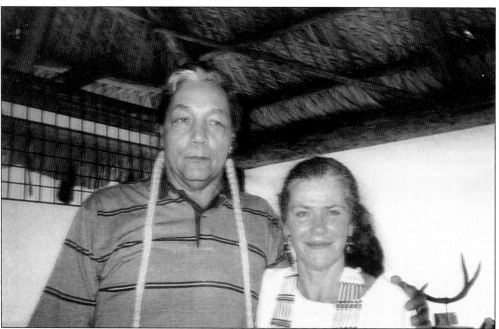

LEONARD LONE EAGLE AND BILLIE SOUTHARD MERIT. (CHOCTAW). This 1998 picture of friends was taken at a Seminole Reservation powwow in Florida. Billie Southard Merit has written two books of poetry and has poems published in 15 books. Three of her poems were recorded, and she is a published photographer. (Courtesy of Billie Southard Merit.)

Six

CHAHTA TVSKA
LUMVT ANUMPULI
(CHOCTAW WARRIORS
CODE TALKERS)

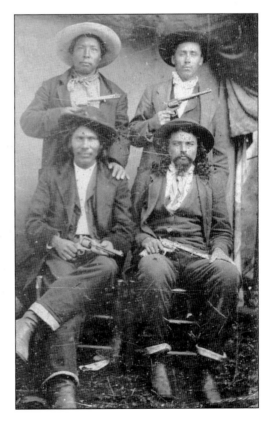

CHOCTAW LIGHT HORSEMEN. Pictured from left to right are (first row) Ellis Austin and Stanley Benton; (second row) unidentified and Peter Cowser. The Choctaw Light Horsemen were an elite police society. American Indians have the highest participation rate of any ethnic group in the U.S. military, often about 50 percent. It is not well known that the Choctaw Indians were the first code talkers as early as World War I. (Courtesy of Choctaw Nation of Oklahoma.)

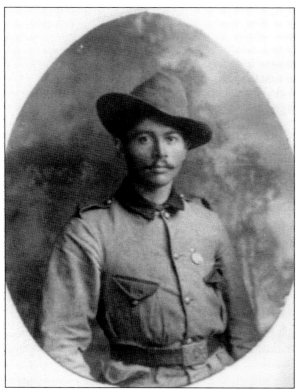

BEN H. COLBERT. Ben H. Colbert was a Spanish American War veteran shown here in uniform. American Indians have the highest participation rate in the U.S. military of any ethnic race and have participated in all the U.S. wars. Approximately 50 percent of American Indians are veterans. (Courtesy of Confederate Memorial Museum and Oklahoma Historical Society.)

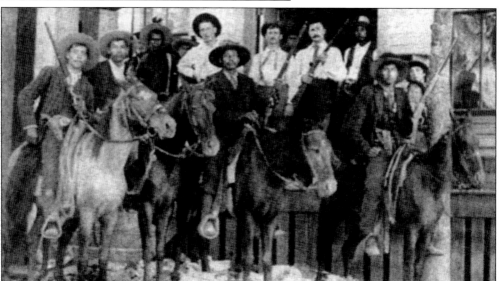

TURNER BRASHEARS TURNBULL JR. AND CHOCTAW LIGHT HORSEMEN. Turner (left) was born in 1851 at Mount Pleasant, nine miles east of Caddo, and this photograph was taken at Antlers around 1893. He married Adeline Dwight of Pigeon Roost. Turner and his brothers organized the Turnbull Rangers to protect stockmen. Brothers Daniel and Leroy were killed by outlaws. Turner died in Caddo in 1908 from chigger bites. The Turnbull Cemetery is at Stuart Ranch, where the author also lived. Choctaw families here were Turnbull, Folsom, Perkins, Cochnauer, Freeny, and Ward. (Courtesy of Choctaw Nation of Oklahoma.)

TOBIAS WILLIAM FRAZIER (CHOCTAW). Tobias Frazier was a Choctaw code talker who served the United States in World War I. Choctaw code talkers played an important role in sending messages in the Choctaw language. It is not well known that Choctaw Indians were code talkers as early as World War I. They were the first to use their native language in World War I, and again in World War II. The German army never deciphered the Choctaw messages. (Courtesy of Confederate Memorial Museum and Oklahoma Historical Society.)

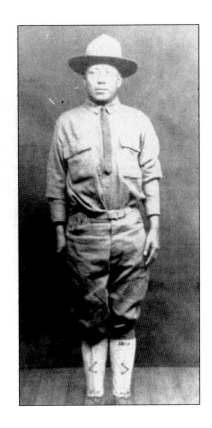

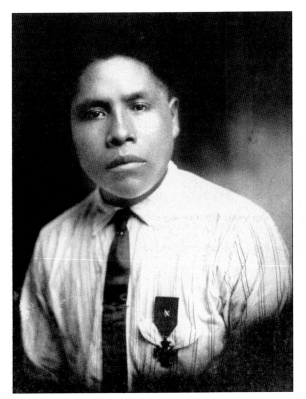

JOSEPH OKLAHOMBI (CHOCTAW). Pvt. Joseph Oklahombi was a Choctaw doughboy and code talker in World War I who helped the American Expeditionary Force win key battles in the Meuse-Argonne Campaign in France. Oklahombi was from Wright City and was awarded the Croix de Guerre by Marshal Petain and received citations from Gen. John J. Pershing. He was killed in an accident near his home in 1960. (Courtesy of Oklahoma Historical Society and Confederate Memorial Museum.)

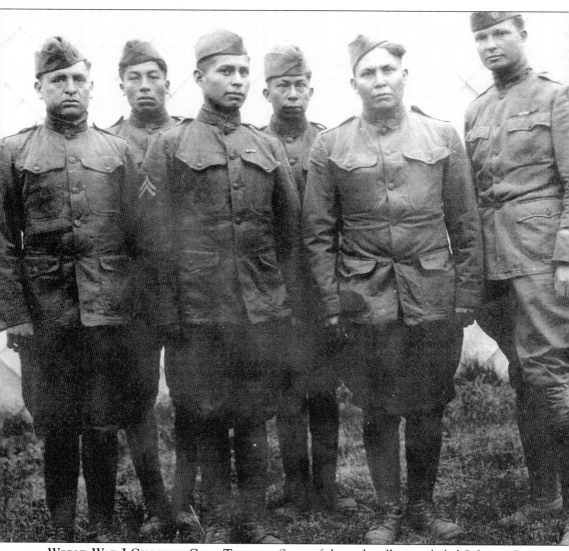

WORLD WAR I CHOCTAW CODE TALKERS. Some of the code talkers included Solomon Louis of Bennington; Mitchell Bobb of Smithville; Ben Caterby (Bismark) of Wright City; Robert Taylor of Bokchito or Boswell; Jeff Nelson of Kullitukle; Pete Maytubby of Broken Bow; James Edwards of Ida (now Battiest); Calvin Wilson of Goodwater; Albert Billy; Victor Brown; Tobias Frazier; Ben Hampton; Joseph Oklahombi; and Walter Veach. (Courtesy of Choctaw Nation of Oklahoma.)

SGT. BOB CARR AND LEWIS FRAZIER (CHOCTAW). Lewis Frazier (right) grew up at Spencerville and attended Spencer Academy. He had three brothers and two sisters: Willie, Jesse, Benjamin, Rosie Frazier Davis, and Mary Frazier David. Lewis married Encie Fobb in 1920, and their son Elam died in combat in Korea. In 1925, Lewis married Semiah John. He worked in sawmills in Broken Arrow. He proudly served his country in the U.S. Army during World War I and is pictured here with Sgt. Bob Carr. (Courtesy of Choctaw Nation of Oklahoma.)

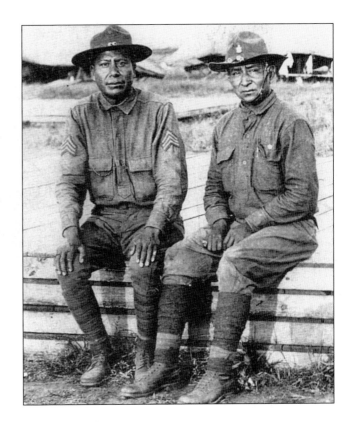

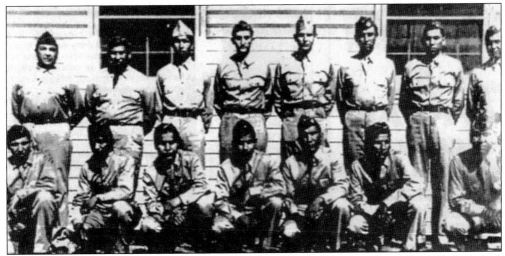

CHOCTAW CODE TALKERS. Pictured from left to right are (first row) Roderick Red Elk, Simmons Parker, Larry Saupitty, Melvin Permansu, Willie Yackeschi, Charles Chibitty, and Willington Mihecoby; (second row) Morris Sunrise, Perry Noyabad, Ralph Wahnee, Haddon "Red" Codynah, Robert Holder, Edward Nahquaddy, Clifford Otitovo, and Forrest Kassanavoid. This group was awarded the French National Order of Merit by French prime minister Pierre Messmer in 1989 for their outstanding services during the D-Day invasion in World War II. (Courtesy of Choctaw Nation of Oklahoma.)

CHOCTAW NATION WAR MEMORIAL. The monuments here at Tuska Homma bear the names of Choctaw servicemen and servicewomen who were killed in World War I, World War II, Korea, Vietnam, Desert Storm, and the War on Terror. In 1986, at the Choctaw Labor Festival, Chief Hollis Roberts presented posthumous Choctaw Nation Medals of Valor to the families of the code talkers. This was the first official recognition given to them. (Courtesy of Choctaw Nation of Oklahoma.)

ROGER HAMILL, BETTY LAWRENCE, AND VIRGIL OTT (CHOCTAW). This 2006 photograph was taken in Durant at the Choctaw Nation Tribal Complex. Roger Hamill (left) works in tribal security. He is from Bennington, and his grandparents include Daniel Sanders and Mary Fobb Sanders. Betty Lawrence is from Broken Bow and works at the tribal office. Her parents are Raymond and Betty Touchstone. Her grandparents are George Touchstone and Lena Costellow. Virgil Ott is from Coalgate and works in administrative security. His wife is Louis Ott, and his parents are Willie Ott and Carrie Billy. His grandparents are Samuel and Emily Ott, and Nicholas Billy and Melissa Folsom. (Courtesy of Donovin Sprague.)

Seven

HIMAk NITTAk CHAHTA OKLA

(TODAY'S CHOCTAW NATION)

CHOCTAW NATION TRIBAL COMPLEX. The complex, seen here in 2004, is located in Durant, Oklahoma, and serves as the headquarters for the tribe. The building was an Indian school, the Calvin Institute, in 1894; at the beginning of the 20th century it became Presbyterian College for Women. Under the leadership of Chief Gregory E. Pyle and Assistant Chief Mike Bailey, the Choctaw Nation is deeply involved in economic development. (Courtesy of Donovin Sprague.)

CHOCTAW NATION TRIBAL COUNCIL. The council members are as follows: District 1, Hap Ward; District 2, speaker Mike Amos; District 3, Kenny Bryant; District 4, Delton Cox; District 5, secretary Charlotte Jackson; District 6, chaplain Joe Coley; District 7, Jack Austin; District 8, Perry Thompson; District 9, Ted Dosh; District 10, Anthony Dillard; District 11, Bob Pate; and District 12, James Frazier. (Courtesy of Choctaw Nation of Oklahoma.)

REUNION AT JONES ACADEMY. Pictured from left to right are (first row) Jimmy Brunner, Mr. Jefferson, unidentified, John Anderson, and Rob Wood; (second row) Cecil Berry, Bertram Bobb, Tom Anderson, possibly Andrew Choate, and Ted LeFlore; (third row) Scorchy Bryant, unidentified, Earl Ohcomer, Lee York, Henry York, and McKinley Taylor Jr. (Courtesy of Jones Academy Museum.)

BILLY PAUL BAKER (CHOCTAW).
Billy Paul Baker was a Choctaw councilman from 1982 to 2002 and is from Bethel, Oklahoma. Baker is a full-blood Choctaw. The Choctaw Nation encompasses 10.5 counties, with 17 community centers, 2 Boys and Girls Clubs, 8 health clinics, a hospital, a diabetes center, 13 travel plazas, 8 casinos, 3 manufacturing plants, and 3 modular home manufacturing plants. Many people in the organization play an important part in the success of the tribe. (Courtesy of the Choctaw Nation of Oklahoma.)

WASHINGTON, D.C. Pictured from left to right are Brad Spears, Mike Bailey, Inez Sitter, Sen. James Inhofe, and Joy Culbreath. Inez Sitter was honored for 62 years of service as a librarian at Jones Academy. She was married to Frank Sitter for 62 years until his death. Frank worked at Jones Academy for 34 years. Brad Spears is administrator of Jones Academy. Mike Bailey began his schooling at Grant and is a former administrator at Jones Academy and assistant chief of the Choctaw Nation, James Inhofe is a U.S. senator for Oklahoma. Joy Culbreath is director of education for the Choctaw Nation. (Courtesy of Inez Sitter.)

THERESA RAY BETTS AND ANGIE (DILLON) MORAN. Angie (Dillon) Moran (right) is pictured here with her niece Theresa Ray Betts. Angie is also the sister of Mary Theresa Dillon. They were attending a historical society meeting when this 1985 photograph was taken. (Courtesy of the Ralph Dillon Ray family.)

WILLIE AND REBECCA JONES (CHOCTAW). This picture of Willie Jones and his wife, Rebecca, was taken in Keota in 1969. They met at a gathering of the Trail of Tears between 1910 and 1930. Willie was a full-blood Oklahoma Choctaw, and Rebecca was a full-blood Mississippi Choctaw. Willie was a coal miner, and they traveled to Choctaw churches in eastern Oklahoma. Rebecca was a housewife and used old-time remedies to help cure illnesses. Willie and Rebecca have a daughter, Viola "V" May Jones Harrell. (Courtesy of Berl and V. Jones Harrell.)

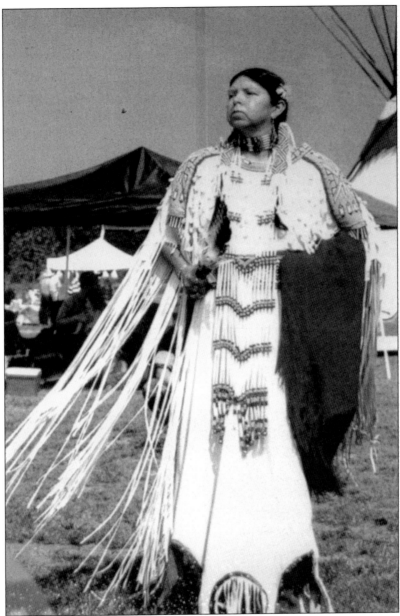

VIOLA "V" JONES HARRELL (CHOCTAW). V Jones Harrell is a full-blood Choctaw of Oklahoma and Mississippi descent. V works with the Indian Intertribal Association of Arkansas to educate the public about traditional lifestyles of the Native American. They hold powwows throughout Arkansas. V has been a traditional dancer since childhood. The eagle feather hairpiece (not visible) is held together by a turtle rosette representing the Choctaw people. The turtle was important to the Choctaw because it has learned to take life slow but is also very strong. (Courtesy of Berl and V. Jones Harrell.)

SUGAR LOAF MOUNTAIN. This 1976 photograph is looking southeast to Sugar Loaf Mountain in Bryan County from a ranch where the author lived. To the west is the community of Matoy, and four miles to the southwest was Armstrong Academy near Banty. The author became familiar with the people and lands of the Choctaw Nation, riding horseback in roundups through large territories and backwoods of Atoka, Bryan, and Choctaw Counties. It was recorded that "Chief Moshulatubbee was buried in one of the unmarked graves just north of Sugar Loaf." (Courtesy of Donovin Sprague.)

JOSHUA CLYDE PICKENS (CHOCTAW/ CHICKASAW). Joshua Pickens's parents were Isiah Cecil Pickens, who was a full-blood Choctaw/Chickasaw, and Nona Carney, a full-blood Choctaw. One-half of the family's American Indian blood was not recorded. Isiah's land holdings were affected by this. The parents of Isiah Pickens were Isom Pickens and Gincy Colbert Pickens. The parents of Nona Carney were Aaron Carney and Nellie Carter. Joshua Pickens married Bertha Wilcox, and their daughter is Patti Pickens. The photograph was taken in 1951. (Courtesy of Patti Scott.)

SHIRLEY JACQUELINE SOUTHARD (CHOCTAW). Shirley Jacqueline Southard, age seven, is seen in this 1942 photograph taken in the western United States. She is the mother of Billie Southard Merit. One grandmother of Billie's was Viola B. Lane. Billie's grandfather was Archie M. Southard, and her paternal grandmother is Ida M. Southard. (Courtesy of Billie Southard Merit.)

JUANITA ESTES (CHOCTAW). Juanita Estes was born in 1920 in Durant and has taught beadwork, loom work, and turquoise, silver, and ceramic work. She taught the author Choctaw beading. Her parents were John Dunn and Susie Thompson, of Talihina. Juanita's husband, Haskell Estes, passed away a few years ago. Their children are Johnny Ray (died at seven months), Mary Sue, Melba Rose, and Charlotte. Juanita's grandmother was Vina Ellington, and her great-great-grandmother was Betsy McCoy. (Courtesy of Donovin Sprague, November 2005.)

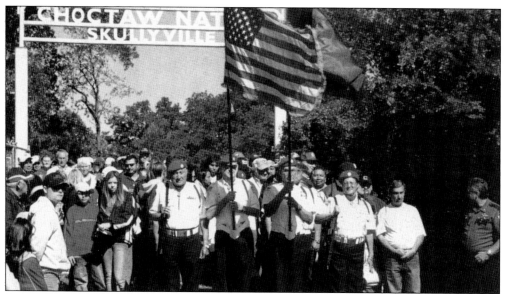

CHOCTAW NATION COLOR GUARD AT SKULLYVILLE. This color guard annual Trail of Tears Commemorative Walk is at the gate of the Skullyville Cemetery in this 2005 photograph. Skullyville comes from the Choctaw word *iskuli*, which means "money." After Choctaw arrival in 1832, Skullyville became a settlement where wealthier Choctaws lived, now LeFlore County. It was a good trading town but declined after the Civil War when the railroads passed it by. The cemetery is designated as the National Cemetery of the Choctaw Nation. (Courtesy of the Choctaw Nation of Oklahoma.)

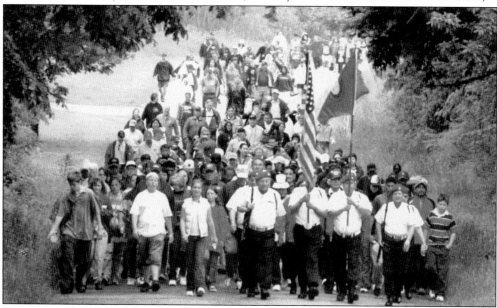

TRAIL OF TEARS WALK. Nearly 1,000 participants follow the color guard in this 2005 annual walk, winding from the Skullyville Cemetery to the Choctaw Center in Spiro. The Choctaw Nation today is the result of positive leadership of the Choctaw people. Under Principal Chief Gregory E. Pyle and Assistant Chief Mike Bailey, the tribe is deeply involved in economic development and numerous jobs have been created. Revenue has created expansions in programs, services, health care, and educational benefits. (Courtesy of Choctaw Nation of Oklahoma.)

LITTLE CHOCTAW GIRL. This unidentified little girl is enjoying some cultural activities and wears a traditional-style dress. (Courtesy of Choctaw Nation of Oklahoma.)

MERIT FAMILY. Pictured from left to right are Dannette Faye Merit, Bobbie Jo Merit, and Sami Louise Merit (Choctaw). This photograph was taken at Huntsville, Alabama, on September 29, 1979, at the state fair. These are the daughters of Billie Merit. Bobbie Jo and Dannette are twins, at age two in this picture. (Courtesy of Billie Southard Merit.)

BERTRAM BOBB (CHOCTAW). Bertram Bobb is the Choctaw tribal chaplain. He has a youth ministry campground at Golden, Oklahoma. As a youth he attended Jones Academy from 1934 to 1946. Bobb was also a Golden Gloves boxer and a tribal councilman. He lives at Antlers, Oklahoma. (Courtesy of Jones Academy Museum.)

CAPITOL BUILDING IN TUSKA HOMMA, LABOR DAY CELEBRATION. Pictured in 1957 are Dollie Clay, Shirley Page, Ruth Castor, Bob Williams, Ola Manion, Wanda Page, and others (Choctaw). (Courtesy of Tom Williams.)

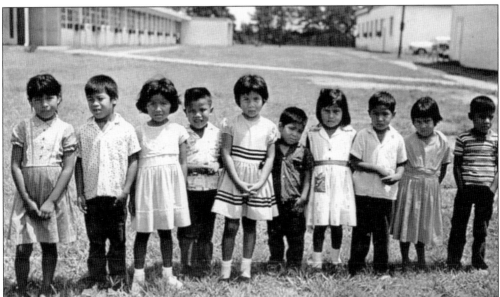

PEARL RIVER INDIAN SCHOOL STUDENTS (CHOCTAW). This is a picture of young Choctaw students at the Pearl River Indian School in Mississippi where the annual Choctaw Indian Fair is held, and one can enjoy colorful costumes of the Choctaw women and stickball games, as stated on this old postcard. The Pearl River Indian School was established in 1920 by the Mississippi Band of Choctaw. The author has visited this tribe near Philadelphia, Mississippi, and explored the historic Natchez Trace in that area, up to Tennessee. (Courtesy of Donovin Sprague.)

BOBBIE JO MERIT (CHOCTAW). Bobbie Jo Merit is the daughter of Billie Merit, and this picture was taken in 1994 at Fort Lauderdale, Florida, when Bobbie was 17. (Courtesy of Billie Southard Merit.)

RUSSELL TRANSUE (CHOCTAW). Russell Transue works at the Jones Academy Museum and Library where this photograph was taken in 2005. His grandfather Cornelius McIntosh attended Jones Academy from 1906 to 1920. Cornelius was born in 1900 and married Lydia Della McNatt in 1924. The parents of Cornelius were Louis McIntosh and Jane Spring. Children of Cornelius and Lydia were Juanita, Cornelius Jr., Melvina Lanning, Eugene, Lester, and a baby who died in infancy. The McIntosh family was from Talihina. Russell provided great assistance to the author. (Courtesy of Donovin Sprague.)

THE WHITEMAN FAMILY. Pictured from left to right are Celia M. Tovar-Whiteman, Henry H. Whiteman, Tommy V. Whiteman, Roger Bratcher, Mary Whiteman-Skaggs, David R. Whiteman, and Herbert A. Whiteman (Choctaw). Henry was born in 1927 in Goodwater and is from the Folsom, Pitchlynn, Harris, Whiteman bloodline of Choctaws. His parents were Henry A. Whiteman and Nora Mae Willis. He married Celia Tovar from Mexico City, and their children are Tommy, Herbert, David, and Mary Ellen. (Courtesy of Tommy V. Whiteman.)

JONES ACADEMY REUNION. Pictured from left to right are George Bohannon, Gilbert Bacon, Edsel Shipley, Johnny James, V. W. Jefferson, Mose Williams, Bill Felker, Cecil James, Bertram Bobb, Melvin Alberson, and Overton Washington (Choctaw). This photograph was taken at Jones Academy and is labeled as "old timers up through 1936." (Courtesy of Jones Academy Museum.)

LeAnne Howe (Choctaw). LeAnne Howe is an author and associate professor of English and American Indian Studies at the University of Illinois at Urbana-Champaign. She is also teaching at the University of Mississippi in Oxford, Mississippi. LeAnne has previously taught at Grinnell College, Carleton College, Sinte Gleska University, and University of Minnesota and was a lecturer at the University of Iowa. She is also a playwright and scholar. Her home is in Ada, Oklahoma. (Courtesy of LeAnne Howe.)

E. J. Johnson (Choctaw). E. J. Johnson and his wife, Marie, had the following children: Jerry LeFlore, Kenneth "K. J." Johnson, Bobby Dean, Richard Johnson (stepson), and Edward and Alvin (both deceased). The daughters are Cleta Faye, Anita Kay, Anna Marie, and Deborah Ann. E. J. attended Jones Academy and served in World War II. He has served on the Choctaw Nation Tribal Council, and one of his hopes is to preserve the Choctaw language. His wife is now deceased, and E. J. has spent much of his life living around Atoka and Lane, Oklahoma. (Courtesy of E. J. Johnson, 1985.)

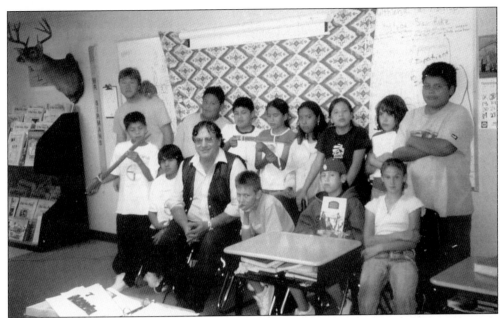

JONES ACADEMY FIFTH-GRADE CLASS. This is a 2005 presentation in Joe Sirmans's fifth-grade class. Pictured from left to right are (first row) Britton Williams, Jeremiah Watkins, Donovin Sprague, Tyler Hedge, Thomas Rush, and Ashley Lawrence; (second row) Joe Sirmans with Little Buddy the squirrel, Miquel Romero, Trevor Holahta, Shalane Black, Stephanie Wallace, Melody Willis, Cheyenne Neal, and Richard Pedro. (Courtesy of Donovin Sprague.)

PATTI SCOTT (CHOCTAW-CHICKASAW). Patti Scott, seen here in November 2005, is the registrar at Jones Academy near Hartshorne, Oklahoma. Her parents are Mr. and Mrs. Josh Pickens. Josh was a student at Jones Academy and in later years worked at the academy in maintenance under the Bureau of Indian Affairs. Josh's parents were I. C. Pickens (Choctaw) and Nona Carney Pickens (Chickasaw). Josh and his parents were full-blood Choctaw and Chickasaw. (Courtesy of Donovin Sprague.)

JONES ACADEMY. Pictured from left to right are teacher Tracy Russell (Choctaw), Shalane Black (Cheyenne-Arapaho), and Cheyenne Neal (Choctaw-Cherokee). Tracy Russell is a fifth- and sixth-grade teacher pictured here with her students Shalane and Cheyenne at Jones Academy near Hartshorne in 2005. Tracy is the daughter of David and Mary Kuy Kendall. In 1988, Jones Academy became a Choctaw tribally controlled school open to students from all tribes in the United States. (Courtesy of Donovin Sprague.)

MORRIS SAM (CHOCTAW). Morris Sam was born in Los Angeles but moved back to his current home of Red Oak in 2004. He is full-blood Choctaw and attended high school at Jones Academy near Hartshorne and now is employed there. His parents are Cornelius Sam and Norma (Carney) Sam. The parents of Cornelius are James Sam and Sophia (Thompson) Sam. Norma's parents are Alton Carney and Juanita Bell Coley. (Courtesy of Donovin Sprague, 2006.)

REBA MCENTIRE. Reba McEntire, seen here on November 18, 1992, and her family are well-known residents from within the boundaries of the Choctaw Nation near Stringtown. She performed for the grand opening of the Choctaw Coliseum in 2006. The large coliseum enables the tribe to host many events and is located just south of Durant near Calera. The tribe will become known for its ability to host major entertainment events. (Courtesy of Donovin Sprague.)

LANE FROST. Lane Frost, world champion bull rider from Lane, resided within the original Choctaw Nation. He was born in 1963 to Clyde and Elsie Frost. Lane's brother and sister are Cody Frost and Robin Muggli. Lane married Kelly Kyle. He died at Cheyenne, Wyoming, while bull riding in 1989. His mentor was Freckles Brown of Soper. Elsie Frost recalled that Lane made a Utah Indian boy his first bull rope. Tuff Hedeman said he did not care if he finished in second to last place as long as Lane was last! Lane is remembered for his rodeo ability, generosity, and humor. (Courtesy of Vern Howell and Clyde and Elsie Frost.)

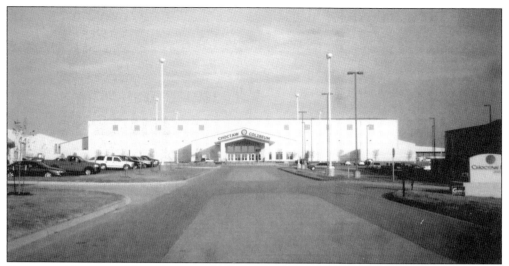

CHOCTAW COLISEUM. The coliseum, seen here in November 2005, opened around Easter 2005 with a religious gathering of about 7,000 people. It is located near Calera. The following weeks featured a graduation ceremony, rodeo, and country music concert by area performer Reba McEntire. An arena is also available for rodeos and horse sales. It is surrounded by a huge Choctaw gaming facility, a tribal convenience store, a truck stop, restaurants, a hotel, and other new facilities. (Courtesy of Donovin Sprague.)

CHOCTAW NATION MEMBERS IN WASHINGTON, D.C. A delegation of Choctaw Nation members attended the grand opening of the National Museum of the American Indian in Washington, D.C. John Paul Jones (Choctaw) was the architect of this new 250,000-square-foot museum. Seen here in this 2004 photograph, the color guard is at the center, and to their left is Chief Gregory E. Pyle, the present Choctaw chief. On the right side of the color guard is Beverly Nelson, Donna Heflin, and Janie Umstead. (Courtesy of Choctaw Nation of Oklahoma.)

GIRLS AT WHEELOCK. These girls are dressed in traditional style at Wheelock Academy. (Courtesy of Choctaw Nation of Oklahoma.)

CHOCTAW NATION TRIBAL COUNCIL. Pictured from left to right in 2004 are (first row) James Frazier, District 12; Mike Amos, District 2; Hap Ward, District 1; and Charlotte Jackson, District 5; (second row) E. J. Johnson, District 10; Ted Dosh, District 9; Perry Thompson, District 8; and Jack Austin, District 7; (third row) Joe Coley, District 6; Delton Cox, District 4; Bob Pate, District 11; and Kenny Bryant, District 3. (Courtesy of Choctaw Nation of Oklahoma.)

RESOURCES

Atoka County Historical Society. *Tales of Atoka County Heritage*. Mt. Vernon, Indiana: Windmill Publications, 1983.

Bryan County History, 1983.

Choctaw Emigration Records 1831–1856, Volume 1.

Dawes Commission Rolls, Choctaw Census 1885, 1896.

Durant, Randle. *Footsteps of a Durant Choctaw*.

Freeny, John Ellis. *Whuppin' and Spurrin' Through Choctaw Country*. Edmond, Oklahoma: 1998.

Indian Citizen newspaper articles: 1892, 1894, 1901, 1902.

Kidwell, Clara Sue and Charles Roberts. *The Choctaws: A Critical Bibliography*. Indiana University Press, 1980.

Norris, L. David and James C. Milligan. *Morrison's Social History of the Choctaw Nation: 1865–1907*. Abilene, Texas: H. V. Chapman and Sons, 2005.

Samuels, Wesley and Charleen. *Life and Times of the Choctaw Original Enrollees*. Published by Wesley and Charleen Samuels, 1997.

West, Shirley Arnote. *Pushmataha County, The Early Years*. Pushmataha County Historical Society, 2002.

Whiteman, Tommy V. *The Crossing of Two Nations*. Self published, 2000.

INDEX

Adams, Richard, 55
Alberson, Melvin, 117
Allison, Lee J., 64
Amos, Mike, 106, 123
Anderson, John, 106
Anderson, Johnny, 83
Anderson, Joshua W., 88
Anderson, Martha. See Dandridge, Martha
Anderson, Tom, 106
Ary, Lucy, 56
Ary, Mary Rebecca. See Briggs, Mary Rebecca
Ary, Thomas Daniel, 56
Austin, Ellis, 99
Austin, Ida. See Whitfield, Ida Austin
Austin, Jack, 106, 122
Austin, Nell. See Pruitt, Nell Austin
Bacon, Alice. See Billy, Alice
Bacon, Gilbert, 117
Bailey, Mike, 105, 107, 112
Baker, Billy Paul, 107
Barnett, Steve, 80
Beal, Dollie. See Billy, Dollie
Beene, Gertrude, 51, 55
Bell, Dwight, 87
Benton, Nathan, 80
Benton, Stanley, 99
Berry, Cecil, 106
Betts, Clyde W., 44
Betts, Theresa, 108
Betts, Wallace W., 44
Bill, Russell, 85
Billie, Barney, 89
Billy, Alice, 60
Billy, Anganora, 60
Billy, Annie, 60
Billy, Byron, 93
Billy, Dollie, 25
Billy, Emily, 18, 25, 60
Billy, Isaac A., 41, 60, 66
Billy, James, 60

Billy, Kyle, 83
Billy, Mahli, 94
Billy, Susan, 36, 60
Billy, William, 60
Black, Shalane, 119, 120
Boatright, Stella, 68
Bobb, Bertram, 106, 114, 117
Bohannon, George, 117
Bond, Annie. See Billy, Annie
Bond, Czarina. See Robb, Czarina
Bond, Dr. Thomas J., 43, 49
Bratcher, Roger, 117
Briggs, Jennie, 25, 51, 68
Briggs, Marion Alvin, 69
Briggs, Mary Rebecca, 56, 70
Briggs, Minnie, 25
Brummitt, Susan. See Billy, Susan
Brunner, Jimmy, 106
Bryan, Hannah, 55
Bryant, Kenny, 106, 123
Bryant, Scorchy, 106
Buck, Charles A., 87
Burleson, Annie. See Billy, Annie
Byington, Cyrus ,14, 74, 75
Byington, Myrtle, 25, 66, 67
Byington, Silas Holson, 60, 67
Byington, Susan. See Billy, Susan
Byrd, Susan, 40
Cantrell, Bill, 68
Cantrell, Melvina, 68
Carnes, Benjamin, 80
Carney, James, 89
Carr, Bob, 103
Cass, Dan, 81
Castor, Ruth, 115
Chibitty, Charles, 103
Choate, Andrew, 106
Clay, Dollie, 76, 115
Clay, Henrietta. See Juzan, Henrietta Clay Hume
Cline, Elizabeth. See Hodges, Elizabeth
Codynah, Haddon "Red," 103
Colbert, Albert Pike, 50

Colbert, Athenius, 35, 42, 45, 48, 50
Colbert, Benjamin Franklin, 39
Colbert, Czarina. See Conlan, Czarina
Colbert, Ben H., 100
Colbert, Lovica. See McBride, Lovica
Coley, Joe, 106
Conlan, Czarina, 45, 57
Cowser, Peter, 99
Cox, Delton, 106, 123
Cruse, Chickie, 30, 31
Culbreath, Joy, 107
Daily, Leroy "Stove Pipe," 89
Dandridge, Martha , 29
Dandridge, Sarah, 29
Dandridge, William A., 29
Davis, Joseph Caesar, 87
Dennison, Kenneth, 89
Dillon, Angie. See Moran, Angie
Dosh, Ted, 106, 123
Drinks the Juice of the Stone, 11
Dunegan, Willie Nelson, 80
Dwyer, Jack, 87
Espinoza, Virginia, 55
Estes, Juanita, 111
Felker, Bill, 117
Flack, Eliza Ann, 45
Folsom, Athenius. See Colbert, Athenius
Folsom, Czarina. See Robb, Czarina
Folsom, Dr. Israel W., 50
Folsom, Rev. Israel, 29, 30, 42, 48, 50
Folsom, Lovica, 29, 30, 48, 50
Folsom, Oscar Jr., 38
Folsom, Sampson, 11
Folsom, Sophia. See Pitchlynn, Sophia
Folsom, Susan. See Byrd, Susan
Fox, Clarence C., 28
Frances, Franklin, 89

Frazier, James, 106, 123
Frazier, Lewis, 103
Frazier, Tobias, 101, 102
Frost, Lane, 121
Fuller, Alabama, 80
Gardner, Jefferson, 20
Gardner, Leroy, 23
Garland, Samuel, 38
Going, Lodie, 61
Golombie, John, 57
Goodnight, Edwin G., 88
Gunter, Addie, 79
Hamill, Roger, 104
Harkins, Katherine. See McClendon, Katherine
Harrell, Berl, 96
Harrell, Viola "V", 63, 96, 108, 109
Harris, Henry, 15
Harris, Henry Churchill, 15
Harris, Walter Churchill, 63
Heard, Irene, 70
Hedge, Tyler, 119
Heflin, Donna, 122
Henry, Solomon, 80
Hicks, Mary, 27
Hocklotubbe, George, 87
Hodges, Elizabeth, 42, 43
Hogue, Rev. R.J., 32, 75
Holahta, Trevor, 119
Holder, Robert, 103
Hotema, Solomon, 15
Howe, LeAnne, 118
Hudson, Irene. See Heard, Irene
Hudson, James, 81
Hume, Henrietta. See Juzan, Henrietta Clay Hume
Imotiskey, Edward, 81
Inhofe, Sen. James, 107
Ishcomer, Lincoln, 33
Ishcomer, Mrs. Lincoln, 33
Isom, Anganora. See Billy, Anganora
Jackson, Charlotte, 106, 123
Jacob, Agnes. See Lewis, Agnes
Jacob, Calvin, 27
Jacob, Nelson, 27
Jacob, Mary. See Hicks, Mary
James, Absolum, 15
James, Burnett, 80
James, Cecil, 117
James, John B., 87

James, Johnny, 117
Jefferson, Clemo, 89
Jefferson, V. W., 117
Jefferson, Wallace, 80
Johnson, E. J., 118, 123
Johnson, Edith, 61
Johnson, Joe, 61
Johnson, Leo, 61
Jones, Harley, 89
Jones, James, 87
Jones, Melvina. See Cantrell, Melvina
Jones, Perry, 61
Jones, Rebecca, 108
Jones, Silsainey. See Ward, Silsainey
Jones, Viola "V." See Harrell, Viola "V"
Jones, Willie, 108
July, Joe, 89
Juzan, Alexander, 32
Juzan, Eliza Ann. See Flack, Eliza Ann
Juzan, Henrietta Clay Hume, 32
Kassanavoid, Forrest, 103
Kennedy, Ella, 68
Ketcheshawno, Betty, 93
King, Jack, 86
Kingsbury, Lucy, 48
Kingsbury, Rev. Cyrus, 37, 46, 48
Kirk, Wood, 15
Lawrence, Ashley, 119
Lawrence, Betty, 104
Leard, Walter F., 88
Lee, Charles, 89
LeFlore, Basil, 26, 59
LeFlore, Chickie. See Cruse, Chickie
LeFlore, Chockie, 31
LeFlore, Forbis, 24, 26
LeFlore, Matilda. See Manning, Matilda
LeFlore, Preston, 81
LeFlore, Ted, 89, 106
Lewis, Agnes, 27
Lewis, Sam, 80
Little Buddy, 119
Littlepage, Lucy. See Kingsbury, Lucy
Lone Eagle, Leonard, 98
Loudermilk, Tommy, 89
Manion, Ola, 76, 115

Manning, Angeline Rebecca, 28
Manning, Matilda, 27, 28
Maxwell, MacKenzie, 94
McBride, Harriet "Hattie," 34
McBride, Lovica, 34, 35, 40
McClendon, Katherine, 47
McClure, James, 76, 85, 89
McCurtain, Green, 20
McEntire, Reba, 121, 122
McGirt, Wallace, 89
McIntosh, Alexander L., 88
McKinney Dancers, 92
McLemore, Emment, 81
McMillan, Erica, 94
Mears, James, 79
Meely, Kenneth, 89
Merit, Billie, 98, 111, 114, 116
Merit, Bobbie Jo, 114, 116
Merit, Dannette Faye, 114
Merit, Sami Louise, 114
Mihecoby, Willington, 103
Mishaya, Emily. See Billy, Emily
Mitchell, Frank, 83
Moore, Anna. See Smallwood, Anna
Moran, Angie, 108
Mose, Joe, 89
Mosholatubbee, Chief, 2, 13
Murrow Indian Orphan's Band, 73
Murrow, Rev. J. S., 45, 72, 73, 75, 85
Nahquaddy, Edward, 103
Nail, Jonithan, 54
Nail, Lovica. See Folsom, Lovica
Nelson, Beverly, 122
Newkirk, Annie. See Billy, Annie
Noahubbe, Nelson, 81
Noyabad, Perry, 103
Neal, Cheyenne, 119, 120
Ohcomer, Earl, 106
Oklahombi, Joseph, 101
Oklahombi, Joel Joseph, 57
Otitovo, Clifford, 103
Ott, Virgil, 104
Page, Anganora. See Billy, Anganora
Page, John, 59
Page, Shirley, 76, 115
Page, Wanda, 115
Paitilo, Tom, 53

Panter, Elma Mae. See Wall, Elma Mae

Parish, Lizzie. See Taylor, Lizzie

Parker, Nelson, 89

Parker, Simmons, 103

Parmacher, Loyd, 81

Pate, Bob, 106, 123

Paxton, Gabrial, 68

Paxton, Norris, 68

Paxton, Rufus, 68

Paxton, Selina, 68

Paxton, Susan, 68

Paxton, Swinney G., 68

Payton, Noah, 35

Pedro, Richard, 119

Permansu, Melvin, 103

Perry, Dan, 86

Peters, Archie, 80

Peters, Dollie. See Billy, Dollie

Pickens, Joshua C., 81, 90, 110, 119

Piepgrass, Lydia, 85

Pitchchlynn, Peter "Snapping Turtle," 10

Pitchchlynn, Peter Perkins, 12

Pitchlynn, Sophia, 12, 14, 38

Plato, Charles, 88

Pruitt, Nell Austin, 24

Push, Susan. See Paxton, Susan

Pushmataha, 2, 9, 45

Pusley, Lyman, 60

Pyle, Chief Gregory, 105, 122

Ray, Albert W., 54

Ray, Albert, 53

Ray, Arthur, 54

Ray, Bert, 53

Ray, Davie, 54

Ray, Dee Moffett, 54

Ray, Dennis Porter, 54

Ray, Edna, 52

Ray, Harriet, 52

Ray, John Robert, 54

Ray, John, 53

Ray, O. P. Sr., 52, 53

Ray, Oliver Perry II, 54

Ray, Ralph, 52

Ray, Theresa. See Betts, Theresa

Ray, William B. Sr., 54

Red Eagle, Joe, 89

Red Elk, Roderick, 103

Robb, Czarina, 48

Roberts, Lillie, 55

Roberts, Michael, 97

Robot, Father Isadore, 37

Roman, Faye, 61

Romero, Miquel, 119

Rush, Thomas, 119

Russell, Emma. See Telle, Emma

Russell, Tracy, 120

Sam, Morris, 120

Samuels, Leroy, 61

Sanders, Virgil, 89

Saupitty, Larry, 103

Schrock, Frances, 40

Scott, Patti, 119

Scott, Wayne, 89

Shipley, Edsel, 117

Sirmans, Joe, 119

Sitter, Inez, 77, 107

Smallwood, Anna, 51

Smallwood, Benjamin F., 10

Smiser, Miss Earl, 57

Southard, Billie. See Merit, Billie

Southard, Shirley Jacqueline, 111

Spears, Brad, 107

Sprague, Donovin, 119

Spurlock, Agnes Joy, 79

Sunrise, Morris, 103

Swinney, Joe, 89

Taylor, Jennie. See Briggs, Jennie

Taylor, Lizzie, 65

Taylor, McKinley Jr., 106

Taylor, McKinley Sr., 55, 65

Tekubie, Faye. See Roman, Faye

Tekubie, Wanonda Marie, 61

Telle, Alinton Russell, 61, 62

Telle, Emma, 61, 62

Thompson, Giles, 58

Thompson, Perry, 106, 123

Tonika, Bertha Mae, 61

Tovar-Whiteman, Celia M., 117

Townsend, Jenny, 94

Transue, Russell, 116

Turnbull, John, 15

Turnbull, Turner Brashears Jr., 100

Umstead, Janie, 122

Underhill, Jerry, 80

Utley, James, 59

Wade, Alfred, 59

Wahnee, Ralph, 103

Wall, Clarence, 67

Wall, Elma Mae, 67

Wallace, Stephanie, 119

Ward, Bertha Mae. See Tonika, Bertha Mae

Ward, Hap, 106, 123

Ward, Joseph R. Hall, 69

Ward, Reed, 61

Ward, Silsainey, 61

Ward, Warren, 87

Washington, Overton, 117

Watkins, Jeremiah, 119

Watson, Curtis, 83

Watson, Jessie, 61

Watson, Ruth, 61

Webber, Johnny, 83

Wells, Susan. See Paxton, Susan

West, Gertrude. See Beene, Gertrude

West, Jennie. See Briggs, Jennie

White, Joy, 77

Whiteman, David R., 117

Whiteman, Henry H., 117

Whiteman, Herbert A., 117

Whiteman-Skaggs, Mary E., 117

Whiteman, Tommy V., 117

Whitfield, Ida Austin, 24

Williams, Bob, 115

Williams, Britton, 119

Williams, Frances, See Schrock, Frances

Williams, Mose, 117

Williams, Myrtle. See Byington, Myrtle

Williams, Tom, 65

Willis, Clarence, 88

Willis, Melody, 119

Willis, Perry M., 88

Wilson, Edward, 15

Wilson, James, 89

Wilson, John, 15

Wilson, Raphael, 15

Wilson, Willie, 15

Winship, Eliza, 95

Winship, Mary, 95

Wood, Rob, 106

Wood, Robert H., 80

Wright, Allen, 46, 58, 59, 61, 72

Wright, Mrs. Robert, 89

Yackeschi, Willie, 103

York, Henry, 106

York, Lee, 106

ACROSS AMERICA, PEOPLE ARE DISCOVERING SOMETHING WONDERFUL. THEIR HERITAGE.

Arcadia Publishing is the leading local history publisher in the United States. With more than 3,000 titles in print and hundreds of new titles released every year, Arcadia has extensive specialized experience chronicling the history of communities and celebrating America's hidden stories, bringing to life the people, places, and events from the past. To discover the history of other communities across the nation, please visit:

www.arcadiapublishing.com

Customized search tools allow you to find regional history books about the town where you grew up, the cities where your friends and family live, the town where your parents met, or even that retirement spot you've been dreaming about.